Harry Potter

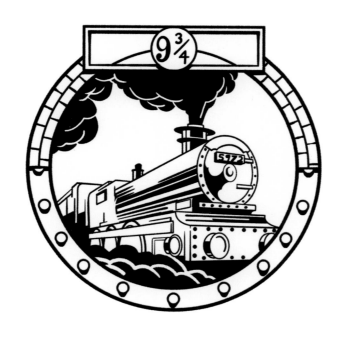

FILM VAULT

Volume 2

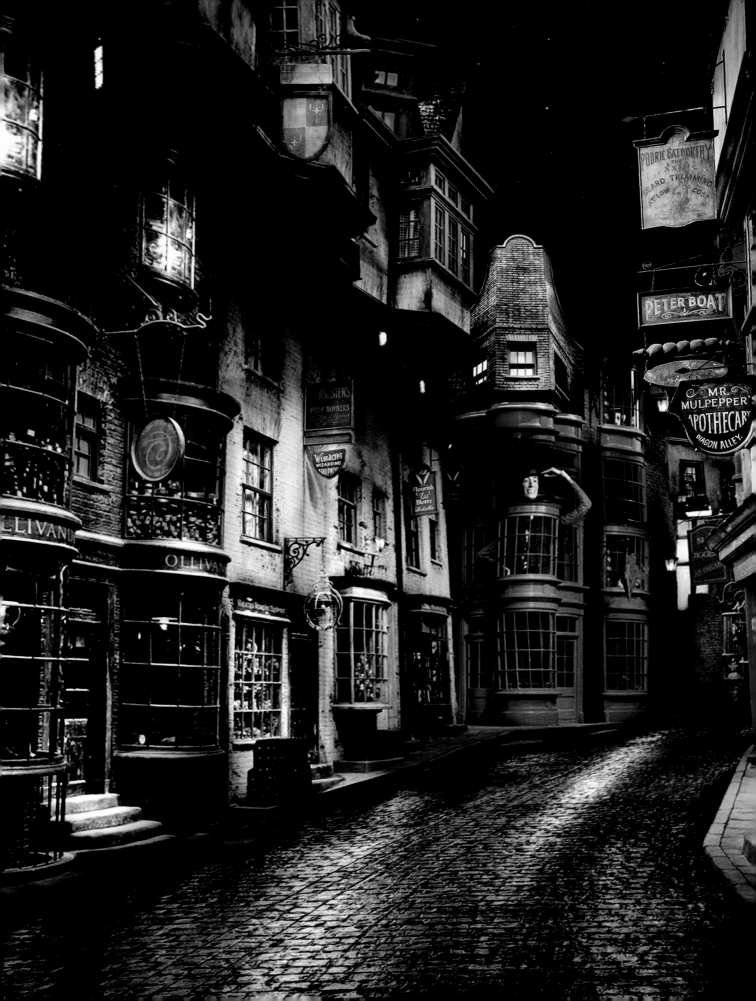

FILM VAULT

VOLUME 2

Diagon Alley, the Hogwarts Express, and the Ministry

By Jody Revenson

WIZARDING WORLD™

INSIGHT ◉ EDITIONS

San Rafael, California

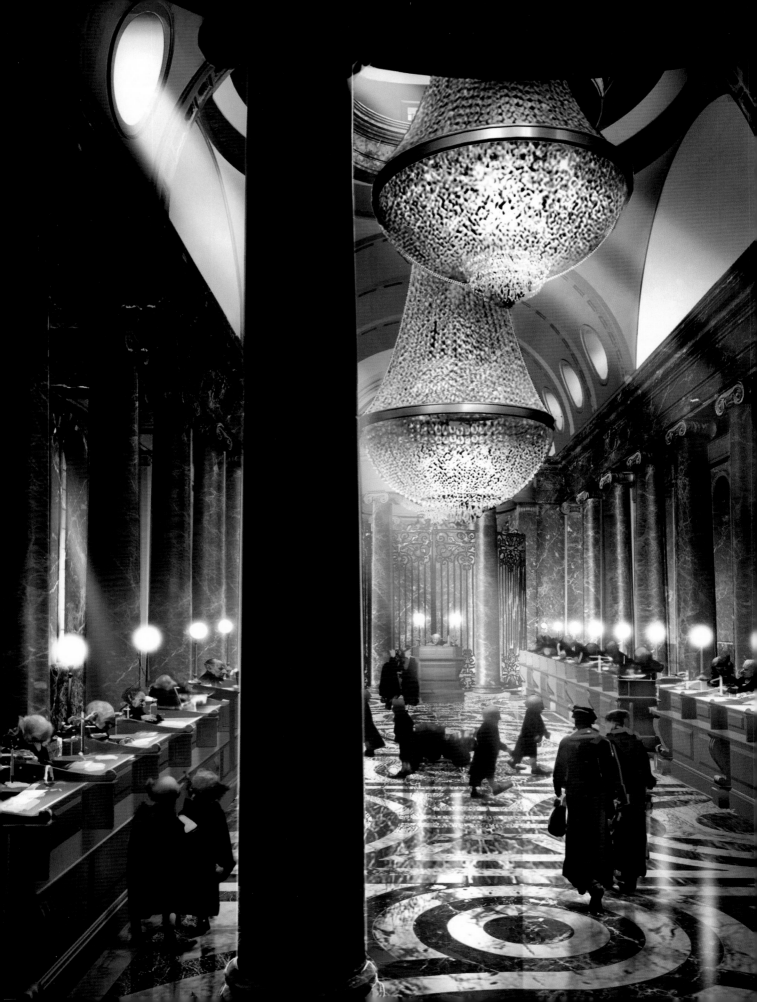

INTRODUCTION

When Harry Potter receives a letter inviting him to Hogwarts School of Witchcraft and Wizardry, he not only learns that he's a wizard but that wizards have been living alongside Muggles (non-magic folk) for centuries. However, as the wizarding community needs to protect access to their world, entering these places takes, of course, a bit of magic.

Tasked with bringing the wizarding world to the movie screen, production designer Stuart Craig and set decorator Stephenie McMillan followed philosophies of plausibility and possibility for whatever they created for or chose to populate the locations. "I personally think whimsy would have been a bad idea," says Craig. "I think whimsy implies that anything goes, and that things are not the shape or the way they are because of necessity or an underlying logic or purpose. I think if we'd gone that way with these films, it would have been fairly disastrous."

In addition to consulting the Harry Potter novels, Craig and his team researched the various places where J.K. Rowling set her story. Harry's first glimpse of his new world, in *Harry Potter and the Sorcerer's Stone*, is at the Leaky Cauldron, a wizard pub set off Charing Cross Road in central London. All through the city there are pubs resembling the Leaky Cauldron, with chalkboard menus, roaring fireplaces, and shadowy tables. Some of the buildings date back to the 1500s, with patterned brick walls and molded plasterwork held up with heavy timbers. Of course, there are none (that we know of) with a magical brick wall out back that opens up to Diagon Alley. Accompanied by Rubeus Hagrid, gamekeeper and Keeper of Keys and Grounds at Hogwarts, Harry enters the wizarding marketplace, which teems with shops selling potions, brooms, cauldrons, and wands. The architecture of Diagon Alley is a mash-up of several styles, similar to other London markets. "Everything is about the window and the stallboard outside," says Craig.

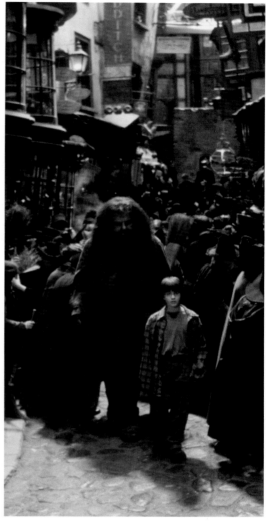

OPPOSITE: *Gringotts concept art by Andrew Williamson for* Harry Potter and the Deathly Hallows - Part 1. RIGHT: *Harry's first visit to Diagon Alley.* BELOW: *A prop map of Diagon Alley that hung inside the Leaky Cauldron set.*

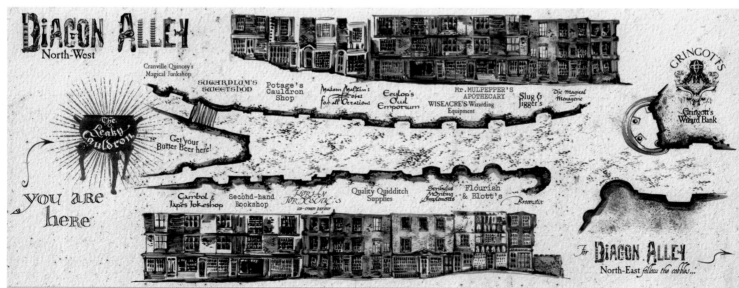

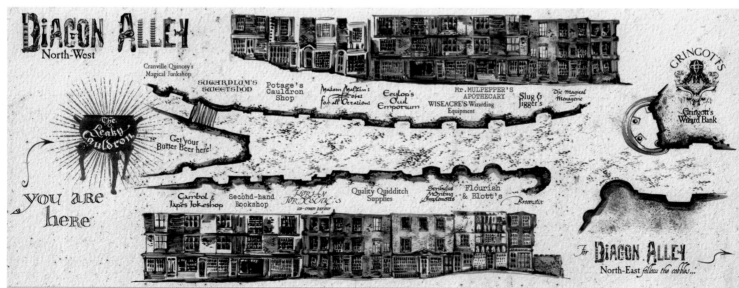

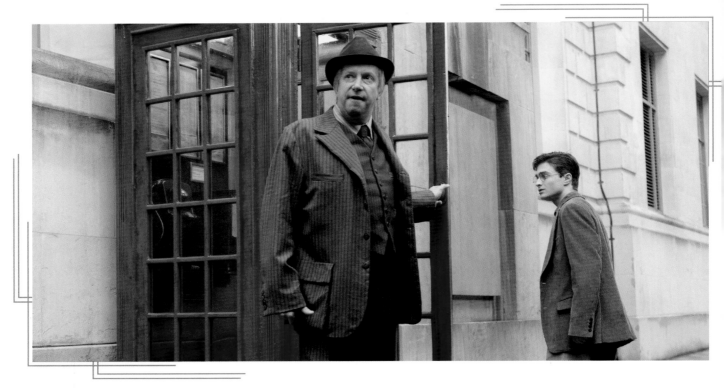

"Stuart has an extraordinary ability to take the familiar and tweak it just enough so that it remains intuitively recognizable yet somehow novel," says producer David Heyman. "Diagon Alley, for example, appears at first glance to be a rather interesting cobblestone street full of shops. But what you may not realize right away is that there are no right angles."

The Hogwarts Express, the train Harry and his classmates take to the wizarding school every year, is reached by going to Platform Nine and Three-Quarters at King's Cross station. Scenes filmed at the platform location required a great deal of luggage for all the students boarding the train. "All the main characters have their own trunks with their initials and the school crest," says Stephenie McMillan. They also needed cages for owls, rats, cats, and other pets. "I remember our shopping assistant trolling around the pet stores trying to find as many different shapes of cat baskets as possible."

In *Harry Potter and the Order of the Phoenix*, Harry visits the Ministry of Magic for the first time, for a trial that will be held in the Department of Mysteries. Stuart Craig knew that this Ministry was equivalent to the Muggle British government, and in fact, sat underground beneath Whitehall, which houses the British civil service and government offices. The Ministry of Magic is typically accessed through the Floo Network, a mode of transport in which a wizard or witch goes from one place to another by means of Floo Powder and a fireplace. But as an underage visitor, Harry must enter from the outside. Escorted by Arthur Weasley, he enters through one of the ubiquitous red telephone boxes on the street. Inside, the magic starts—literally—as dialing a particular number (64224) lowers guests into the Ministry.

"Each setting was so familiar and relatable," says Heyman, "it removed it from being otherworldly and fantastical, and made it feel possible. It made that magical world feel as if it was a world that was connected to my world. And, who knows, maybe, just maybe, there is that place out there. And, if there isn't, boy, would I love there to be."

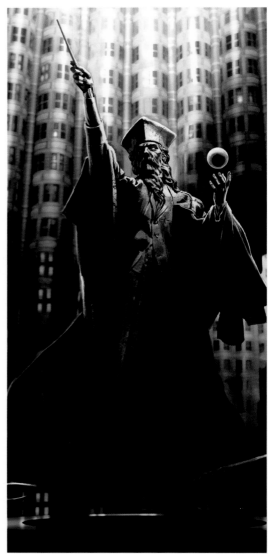

TOP: *Arthur Weasley escorts Harry through the visitors entrance of the Ministry of Magic in* Harry Potter and the Order of the Phoenix. RIGHT: *Concept art by Adam Brockbank for* Order of the Phoenix. OPPOSITE: *Concept art by Andrew Williamson for* Order of the Phoenix.

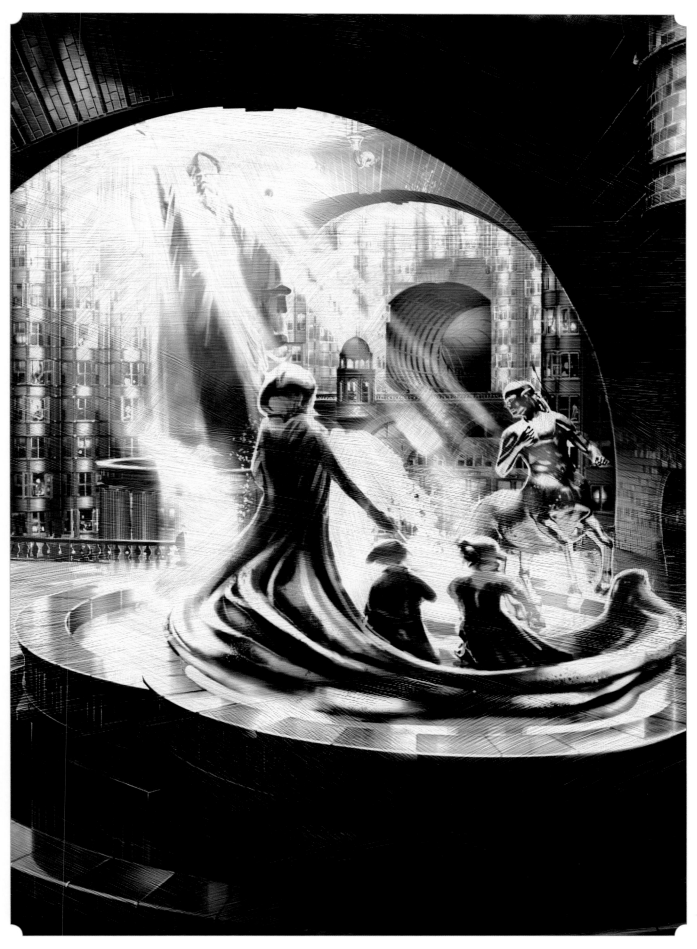

CHAPTER 1

DIAGON ALLEY

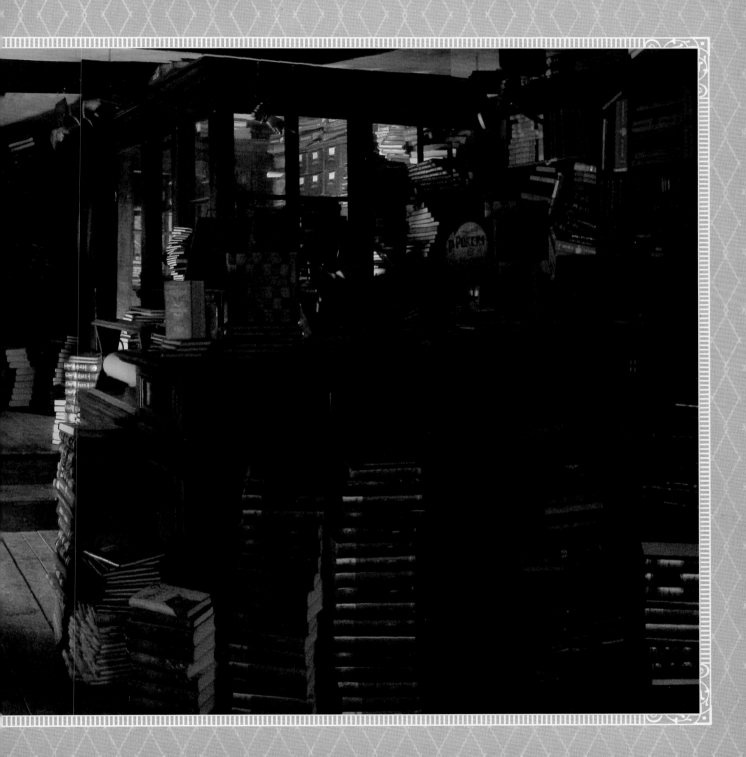

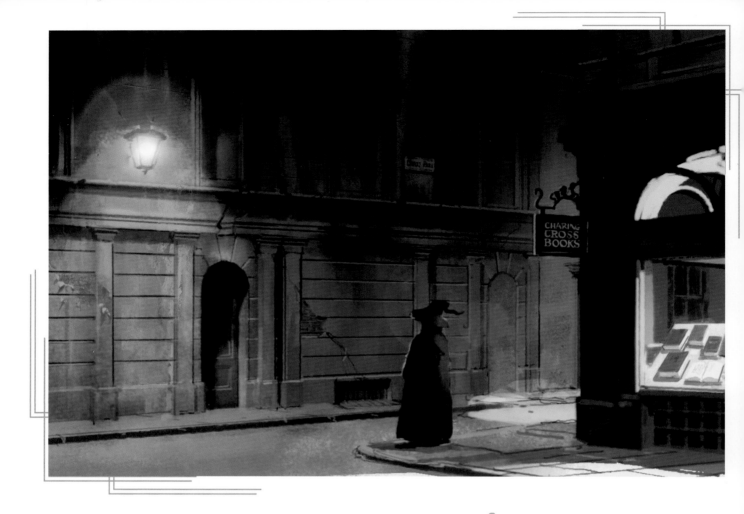

THE LEAKY CAULDRON

In *Harry Potter and the Sorcerer's Stone*, Rubeus Hagrid brings Harry to the Leaky Cauldron, a London tavern and inn, and reveals it to be the entryway to Diagon Alley and the wizarding world. Behind a nondescript door lies a large dining area complemented by a huge fireplace that blazes under a Tudor-style arch. In the tavern, interior walls of plastered-over brick are framed by long wood beams and tall, trefoiled windows. A chalkboard advertises the Cauldron's luncheon fare, which includes roast hog, game pie, and pickled eel.

Harry returns to the Leaky Cauldron, having been picked up by the Knight Bus, in *Harry Potter and the Prisoner of Azkaban*, where he stays the night before leaving for Hogwarts. While there, Harry also meets the Minister for Magic, Cornelius Fudge, in a private parlor, which is encased in the dark, weathered wood panels that characterize Tudor style. Harry stays in room eleven on the second floor, which has simple plastered walls and a bed with ornately carved bedposts and headboard. "The Tudor room and its Tudor bed were a deliberate choice," says Stuart Craig, "to reinforce the idea that the wizarding world has a different timescale." The view from the window is of London's Borough

> OCCUPANTS: Tom, the owner; visiting witches and wizards
>
> FILMING LOCATION: Leavesden Studios
>
> APPEARANCES: *Harry Potter and the Sorcerer's Stone, Harry Potter and the Prisoner of Azkaban*

Market and the towers of Southwark Cathedral. The corridor, where a chambermaid attempts to provide room service, was created utilizing forced perspective, a time-honored technique used in set decoration that compresses relative heights in order to make places appear taller or longer. In what is in reality ten or so feet of corridor, the illusion of fifty feet is created. As with so many of the visual effects in the *Harry Potter* films, practical solutions could be just as applicable as computer-generated ones, and, as Craig describes, "this was much less expensive and a lot more fun."

THESE PAGES, CLOCKWISE FROM TOP LEFT: *Concept art of the Leaky Cauldron exterior by Andrew Williamson, created for* Harry Potter and the Prisoner of Azkaban; *two views of the Leaky Cauldron set; the dining area as seen in* Harry Potter and the Prisoner of Azkaban; *other Leaky Cauldron set highlights, including signage, the desk used by Cornelius Fudge, and a pub menu.*

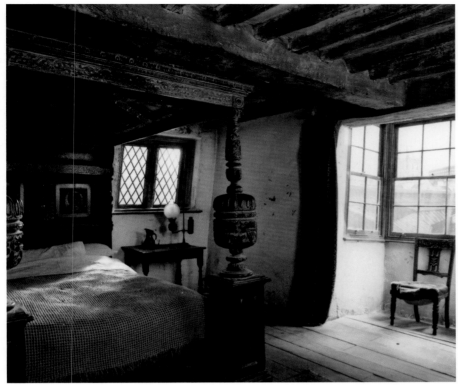

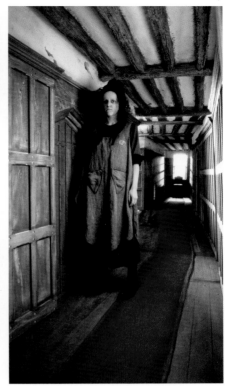

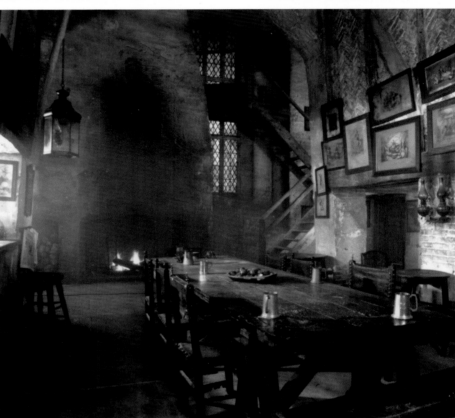

"DID YOU HEAR THAT, ERN? THE LEAKY CAULDRON.
THAT'S IN LONDON."

Stan Shunpike, *Harry Potter and the Prisoner of Azkaban*

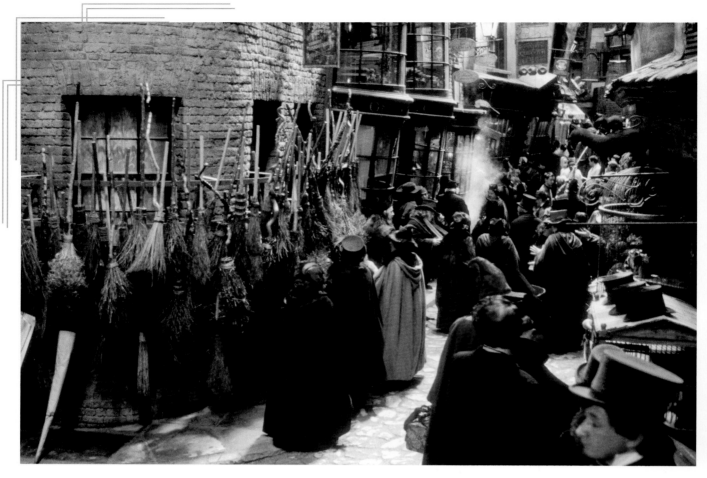

DIAGON ALLEY

In the films, Diagon Alley is Harry Potter's first introduction to the wizarding world, and it is the film audience's as well. Here, the latest Quidditch brooms are for sale, wizard authors give book signings, and young Hogwarts students can acquire their required supplies—cauldrons, quills, robes, wands, and perhaps an owl, toad, or rat.

"Diagon Alley was one of the first sets we created for *Harry Potter and the Sorcerer's Stone*," recalls Stuart Craig. "We started with the notion of a Dickensian-type street." During his research of the time period, Craig noted that buildings had an interesting structural inclination. "Very, very early Victorian architecture had this gravity-defying *lean*. So we began to explore the idea of architecture that was leaning so much it would appear to be falling over." He also added elements of Tudor, Georgian, and Queen Anne styles for a

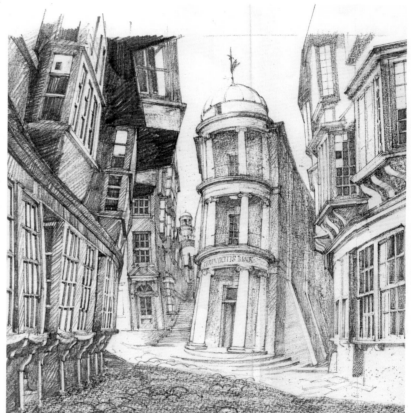

THESE PAGES, CLOCKWISE FROM TOP LEFT: *Diagon Alley shoppers gather near the Magical Menagerie in a scene from* Harry Potter and the Sorcerer's Stone; *views of the Diagon Alley set, including the storefronts of Sugar Plum's Sweetshop and Eeylops Owl Emporium; Hagrid (Robbie Coltrane) and Harry make their way through the alley in* Harry Potter and the Sorcerer's Stone; *a sketch showing the entrance to Gringotts.*

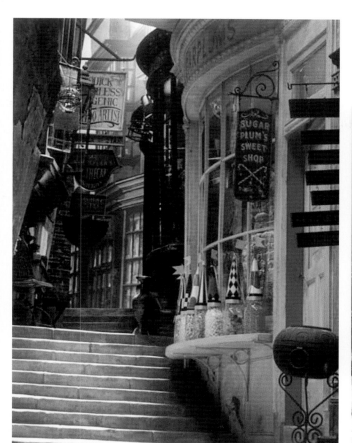

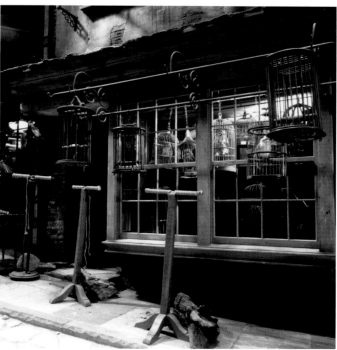

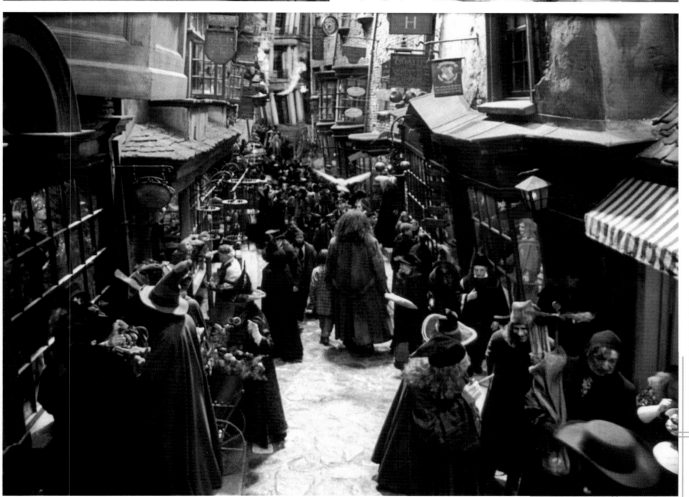

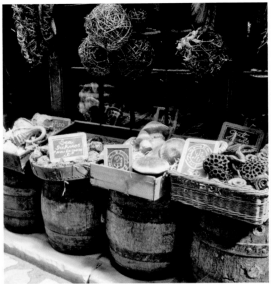

unique architectural mash-up. Director Chris Columbus and Stuart Craig then scouted the London streets, searching for a practical location to film Diagon Alley. "We hoped there were still places that actually looked like that Dickensian world existing somewhere in London," explains Columbus, "but there are very few. And if a place did look like that, there would also be something modern there—a phone booth or a grocery store. We could have tried to work around those, but in order to really have the complete idea, we realized we'd have to build it."

Craig felt that the wizarding world wouldn't be overly concerned with imperfections, and so no one would mind buildings that seemed to be holding one another up: "We wanted crumbling, ancient dereliction. Nothing too smart or done up. It's as full of character as we could possibly make it." Chris Columbus wanted the street to feel not only as if it had been there for hundreds of years but "as if it goes on forever." Craig fulfilled this desire with the use of forced perspective and painted backdrops.

Once the look and design of the street were determined, set decorator Stephenie McMillan and her team took on the task of filling the shops with broomsticks, cauldrons, and other wizard necessities. For this and throughout the film series, McMillan and her assistants scoured antique shops, auctions, and flea markets, as well as having the prop makers construct what they needed. For Diagon Alley, "we took the names of the shops from the book, and any contents mentioned, and then expanded upon it," says McMillan. Often a purchased item would be duplicated by the prop shop to create the amount of stock required. "There was a lot of accumulating to do," McMillan laughs. Fortunately, her assistant, an ardent Harry Potter fan, made it her mission to catalogue everything with the precision "of a military operation," McMillan adds. The props buyers who looked in the city and countryside were asked not to explain why they needed so many jars, books, and owl cages. One buyer who was amassing an unusually large amount of broomsticks told the shop owner she had a lot of sweeping to do.

THESE PAGES: *Views from the Diagon Alley set, including street wares perched on barrels and the storefronts of Flourish and Blotts, Florean Fortescue's Ice Cream Parlour, and Slug & Jiggers Apothecary.*

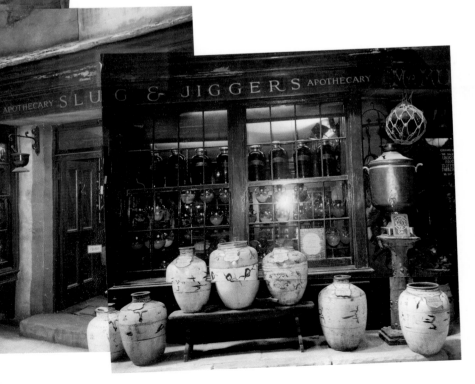

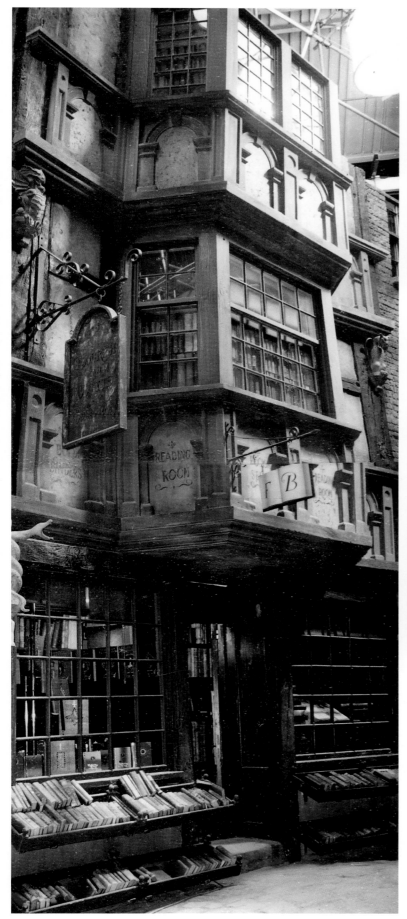

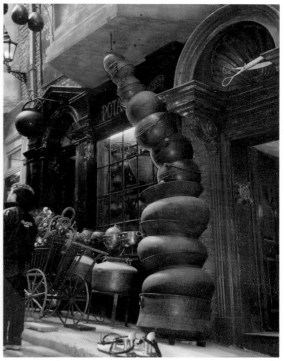

OCCUPANTS: Wizards, witches, goblins, all sort of magical folk and animals

SHOPS: Eeylops Owl Emporium, Potage's Cauldron Shop, Madam Malkin's Robes for All Occasions, Quality Quidditch Supplies, Flourish and Blotts, Gringotts Wizarding Bank, Mr. Mulpepper's Apothecary, Ollivanders wand shop, Weasleys' Wizard Wheezes

FILMING LOCATION: Leavesden Studios

APPEARANCES: *Harry Potter and the Sorcerer's Stone, Harry Potter and the Chamber of Secrets, Harry Potter and the Half-Blood Prince, Harry Potter and the Deathly Hallows – Part 2*

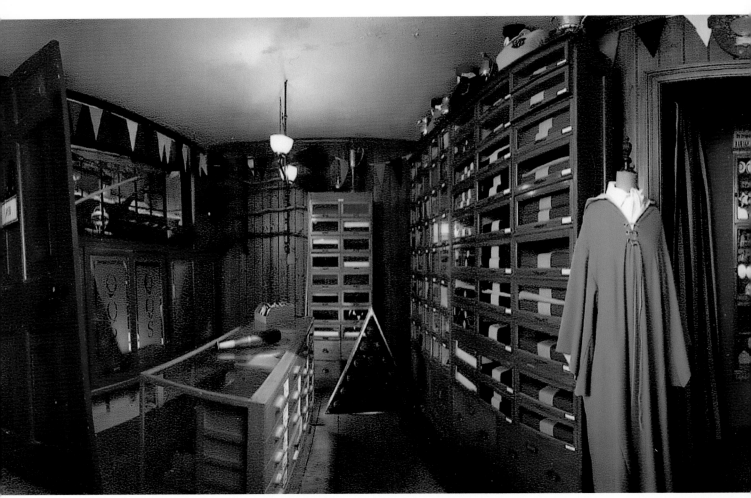

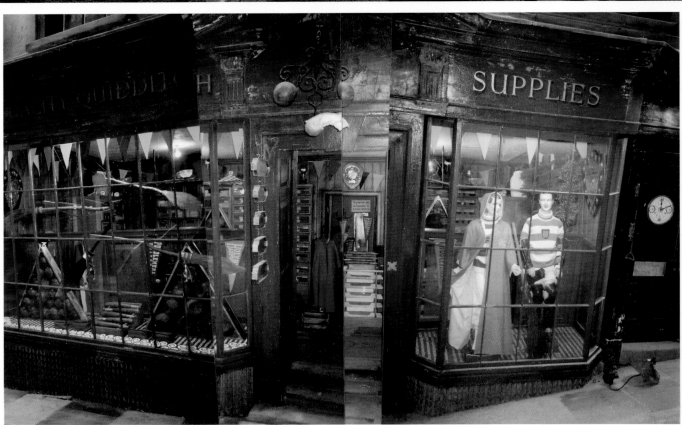

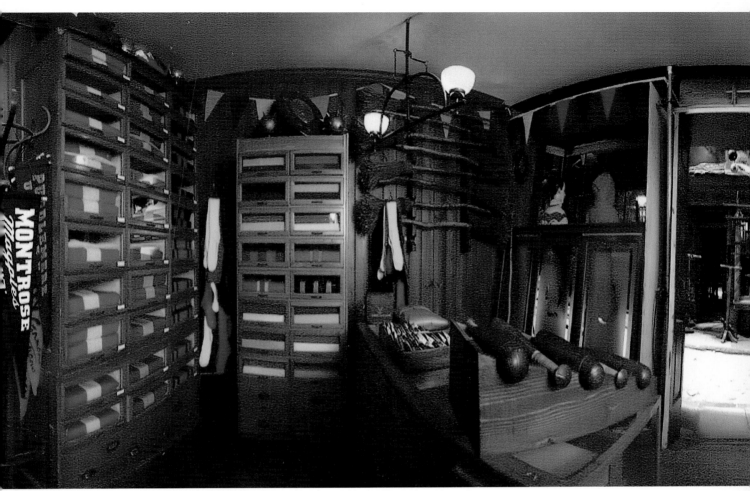

Dressing the set was its own adventure. Stacks of cauldrons teeter in front of Potage's shop; brooms literally hover next to Quality Quidditch Supplies. Mr Mulpepper's Apothecary, a potions shop created for the films and video games, was constructed with shelves ten feet wide and twenty-four feet high. "Only one prop man could dress it at a time," explains McMillan, "and he needed a cherry picker in order to reach all the shelves."

The passion in constructing Diagon Alley and the attention to detail paid off when author J.K. Rowling made a visit to the set. "I wasn't there," says McMillan, "but I was told she just stood there almost with a tear in her eye because it was exactly as she had imagined it from the book." Chris Columbus admitted to being a little nervous before touring the set with Rowling, but "I walked her through Diagon Alley, and she loved it."

THESE PAGES: *The set for Quality Quidditch Supplies was painstakingly dressed with brooms, banners, and uniforms.*

GRINGOTTS WIZARDING BANK

Hagrid takes Harry to Gringotts Wizarding Bank in *Harry Potter and the Sorcerer's Stone* to get money to purchase supplies for Harry's first year at Hogwarts. Run by goblins, Gringotts is, above ground, an impressive, three-story building. Yet the marbled main hall sits atop many strata of underground vaults, the oldest and most protected of which are at the deepest level. The vaults are accessed via twisting tracks traveled by small carts. Stuart Craig wanted Gringotts to exemplify the best attributes of a bank. "Banks are traditionally symbols of stability," he explains. "That is the intention in bank architecture—to convey a feeling of reassurance." For *Harry Potter and the Sorcerer's Stone*, the filmmakers filmed in a real-life location, Australia House, which is the longest continuously occupied foreign mission in London. Australia House's Beaux Arts interior gave Craig the proportions he desired, which contrasted perfectly with its inhabitants. "Everything should conspire to make the goblins look very small and to make the bank look—as banks do—dignified, solid, and important," he says. "So our banking hall, like others, is made of marble, with big marble columns." Desks were created to line the hall, as well as ledgers, quills, and metal coins: Knuts, Sickles, and Galleons, which too frequently disappeared from the set. The lower vaults were built in the studio and visually extended with matte paintings and special effects. The intricate mechanism that clicks and shifts while unlocking the door to vault 687 in *Sorcerer's Stone* and to the Lestrange vault in *Deathly Hallows – Part 2* was a practical effect crafted by Mark Bullimore, who did the same for the snake-locked door to the Chamber of Secrets.

Harry returns to Gringotts with Ron Weasley, Hermione Granger, and the goblin Griphook in *Harry Potter and the Deathly Hallows – Part 2* in

THESE PAGES, CLOCKWISE FROM ABOVE: *Knuts, Sickles, and Galleons designed for the films; concept art depicts one of Gringotts's track-bound carts; detailed receipts were created as props; blue screen was used on the set in* Harry Potter and the Sorcerer's Stone *to film the cart traveling on the track; goblin bankers at work in a scene from* Harry Potter and the Deathly Hallows – Part 2.

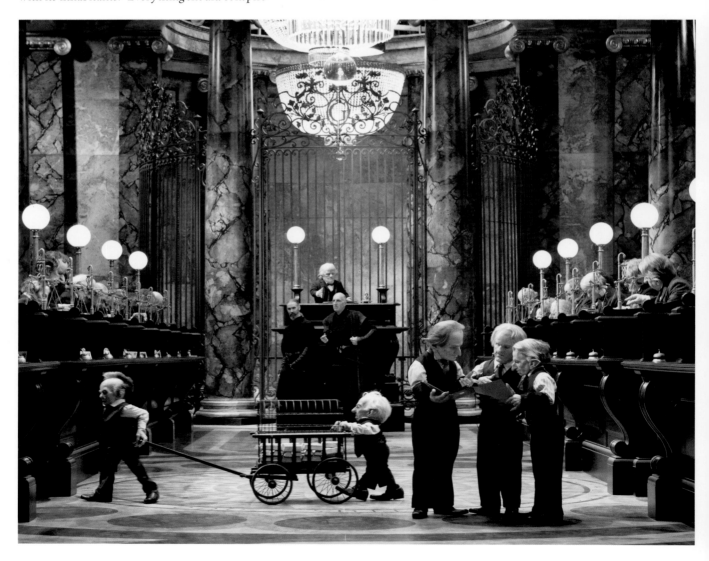

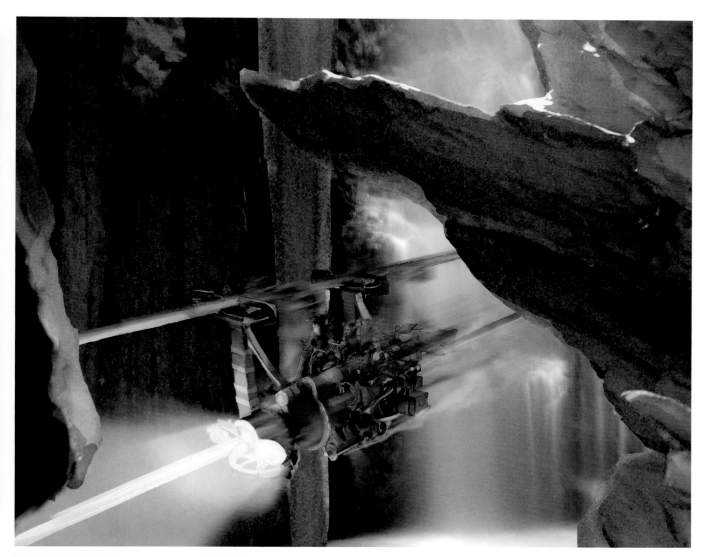

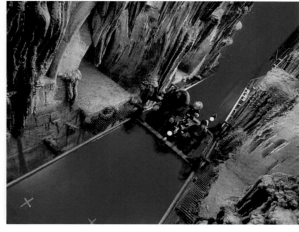

"WELL, THERE'S YOUR MONEY, HARRY. GRINGOTTS, THE WIZARD BANK. T'AIN'T NO SAFER PLACE, NOT ONE, 'CEPT, PERHAPS, HOGWARTS."

Rubeus Hagrid, *Harry Potter and the Sorcerer's Stone*

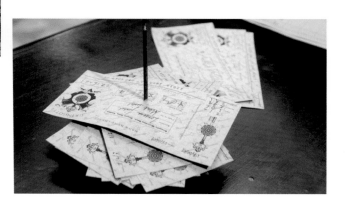

OCCUPANTS: Goblins

FILMING LOCATIONS: Australia House, The Strand, London, England; Leavesden Studios

APPEARANCES: *Harry Potter and the Sorcerer's Stone, Harry Potter and the Deathly Hallows – Part 2*

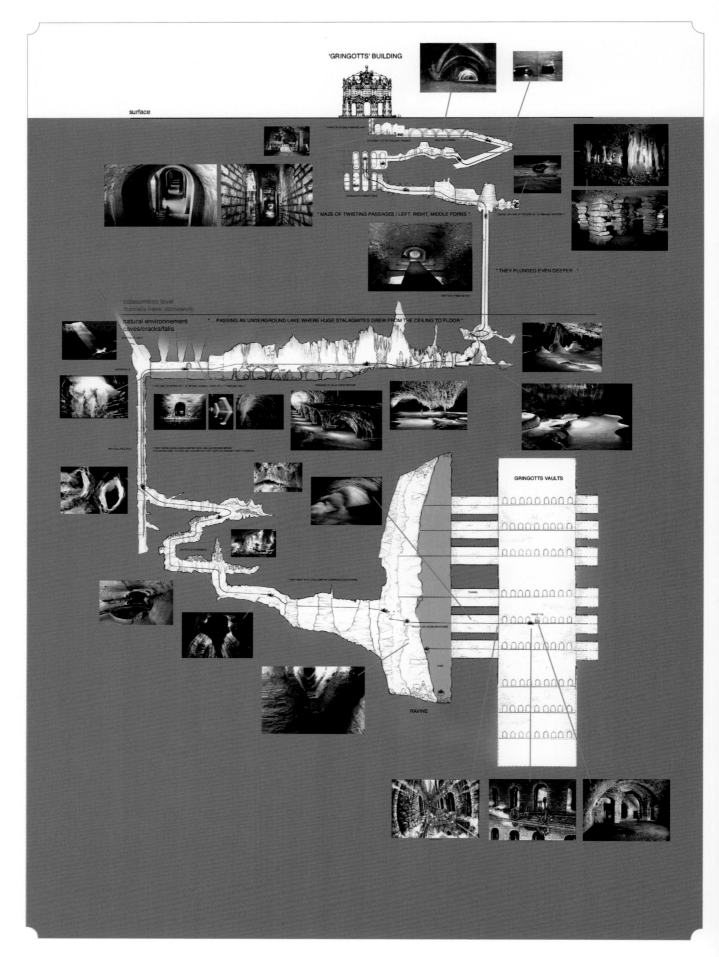

'GRINGOTTS' BUILDING

surface

" MAZE OF TWISTING PASSAGES / LEFT, RIGHT, MIDDLE FORKS ."

" THEY PLUNGED EVEN DEEPER .."

catacombes level
/tunnels have stonework

natural environnement
caves/cracks/falls

" ... PASSING AN UNDERGROUND LAKE WHERE HUGE STALAGMITES GREW FROM THE CEILING TO FLOOR ."

GRINGOTTS VAULTS

RAVINE

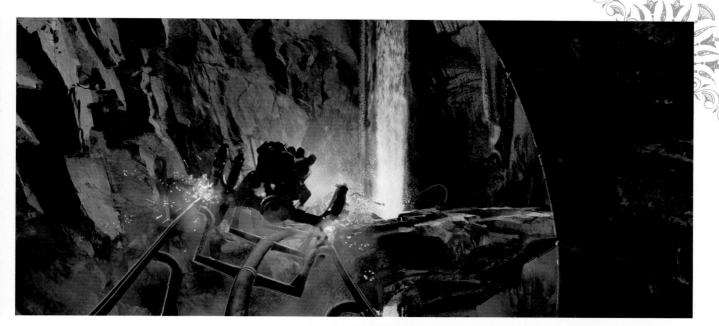

an effort to retrieve a Horcrux from the Lestrange vault, during which the bank is damaged by an escaping dragon. "It smashes out of its pen, smashes through the top of a cave hundreds of feet above, smashes through the banking hall and up through the glass roof. We obviously could not go back to Australia House," says Craig with a smile, and so the bank was duplicated at Leavesden Studios. For this iteration, the marble columns and floor were constructed using paper. "We had quite a considerable faux-marble-making factory," he says, which worked like oil on water—literally. To make marble paper, oil paint is swirled on top of a large, square, water-filled container, then special paper is placed on top. "As you pull the paper up, the oil paint that sticks to it looks very like swirly marble. All that's needed is a bit of finishing brushwork," Craig explains. The design team also utilized large digital printers that made copies of the marbleized paper at widths up to twelve feet. The chandeliers, each with a twelve-foot diameter, were strung with thousands of injection-molded "crystals," which were painstakingly assembled following a precise order. However, he admits, "They were supposed to measure sixteen feet from top to bottom. We made the bottom half physically and then the top half was a computer-generated addition." The bank tellers' props of scales and desks were brought out of storage, with the desks receiving a new paint job and a slightly refined redesign. This time around, the original metal coins were made in plastic and glued together in stacks.

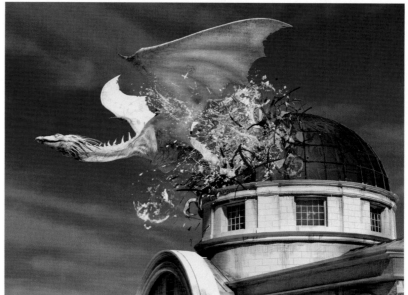

OPPOSITE: *A schematic created for* Harry Potter and the Sorcerer's Stone *diagrams Gringotts's labyrinthine tunnels, showing how the carts (top and right) travel to the vaults.*
ABOVE: *Concept art by Paul Catling depicts the dragon escaping through Gringotts's domed roof.*

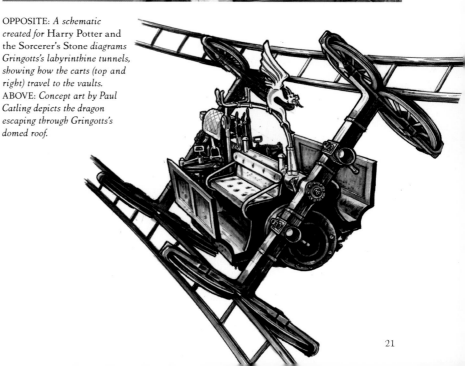

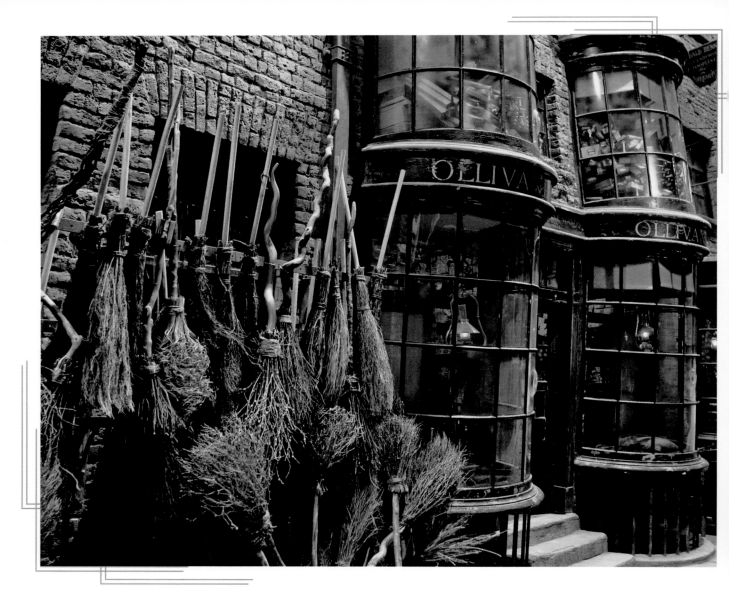

OLLIVANDERS
WAND SHOP

OCCUPANT:
Mr. Ollivander

FILMING
LOCATION:
Leavesden Studios

APPEARANCES:
*Harry Potter and the
Sorcerer's Stone, Harry
Potter and the Half-
Blood Prince*

Every wizard must have a wand, so on his first trip to Diagon Alley in *Harry Potter and the Sorcerer's Stone*, Harry Potter visits Ollivanders, "Makers of Fine Wands since 382 BC."

More than seventeen thousand boxes of wands were stacked, heaped, stuffed, packed, and crammed throughout the shop set for *Sorcerer's Stone*, some on shelving that reached seventeen feet high. The store's uppermost wand boxes were reached by twelve-foot-high sliding ladders. Each wand box was individually affixed with a choice of labels containing information about the wand's core, its type of wood, or other identifying data written in runes, alphabets, and script styles from many different eras and countries. Some even had tassels or cording attached. Then the boxes were aged and overlaid with dust to convey the impression that Ollivanders' wand stock has

been around for a very long time, each wand waiting to choose its witch or wizard.

Stuart Craig enjoyed the character of the Ollivanders set. "It's dense and compact: rich in detail, quite modest in size." The success of the dark set, with its extensive use of various shades of black, encouraged Craig when creating other similarly shadowy, dim locations. "The furniture and woodwork were painted with an ebonized effect: literally black paint on oak, and then rubbed back so that the grain of the wood can show through. Antiques, and particularly Jacobean ones, are like that, and I think we've employed it throughout the films to good effect."

ABOVE: *The dark ebony storefront of Ollivanders wand shop.*
OPPOSITE: *Mr. Ollivander (John Hurt) searches for the right wand for the young Harry Potter in* Harry Potter and the Sorcerer's Stone.

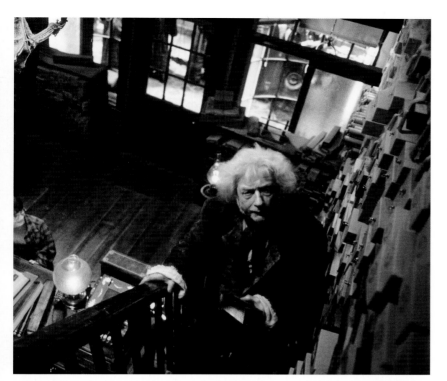

"A WAND? WELL, YOU'LL WANT OLLIVANDERS. T'AIN'T NO PLACE BETTER."

Rubeus Hagrid, *Harry Potter and the Sorcerer's Stone*

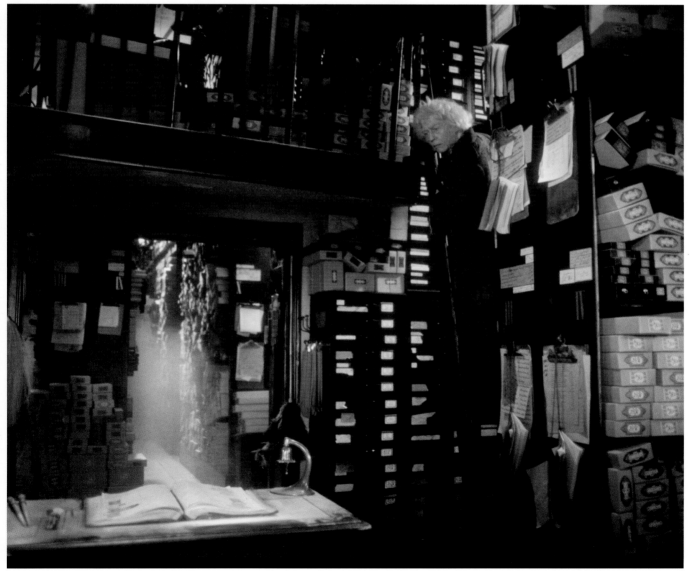

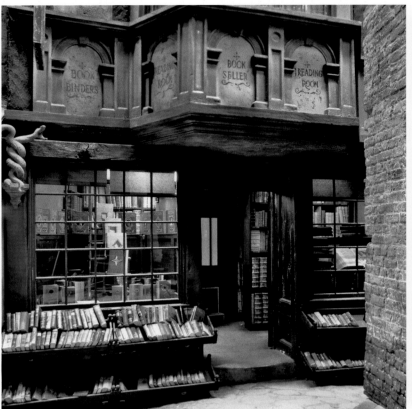
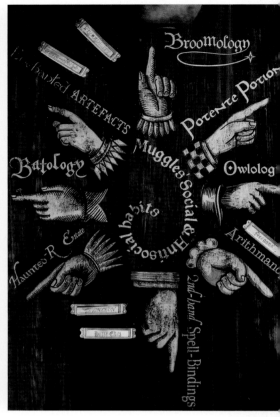

"WHAT AN EXTRAORDINARY MOMENT THIS IS, WHEN YOUNG HARRY STEPPED INTO FLOURISH AND BLOTTS THIS MORNING TO PURCHASE MY AUTOBIOGRAPHY *MAGICAL ME.*"

Gilderoy Lockhart, *Harry Potter and the Chamber of Secrets*

FLOURISH AND BLOTTS

Flourish and Blotts is a wizarding shop where, among other tomes, students can pick up their course books for each year's curriculum at Hogwarts. In *Harry Potter and the Chamber of Secrets*, Flourish and Blotts hosts a book signing for the publication of Gilderoy Lockhart's *Magical Me*, attended by many wizarding families, including the Weasleys and the Malfoys.

While the exterior of Flourish and Blotts is that of a straightforward "bookshop," its interior decoration complements the aesthetic Stuart Craig created for Diagon Alley, with its "slightly impossible spirals of books that don't conform to the laws of physics and the natural world," he explains. "I think it works better for magic if it takes you by surprise. When you walk into an environment, you think you understand it. But then if something strange and magical grows out of that, it has a great surprise element." The Flourish and Blotts set was actually a redress of Ollivanders.

The set decoration and graphics departments embellished the shop with gilt-colored signage that pointed to sections on arithmancy, invisibility, and historical sorcery. The stacks also haphazardly held books on the "ologies": batology, owlology, and broomology, as well as wand welfare and broomstick maintenance, Muggles' social and historical habits, and "elf and safety." The graphics department, headed by Miraphora Mina and Eduardo Lima, created the books for all the films, binding them in cloth and leather in dark earth tones with gilded pages. Mina and Lima were informed by J.K. Rowling that the books for Lockhart should be treated more like "trashy airport novels," and so his books were bound with obviously fake leather in garish, shiny colors.

OCCUPANTS:
Books, books, and more books

FILMING LOCATION:
Leavesden Studios

APPEARANCES:
Harry Potter and the Chamber of Secrets, *Harry Potter and the Half-Blood Prince*

ABOVE: *The Flourish and Blotts storefront and gilt-colored signage.* OPPOSITE: *A curved metal bar was run through holes drilled in the books to give the floor-to-ceiling stacks of tomes their gravity-defying bend.*

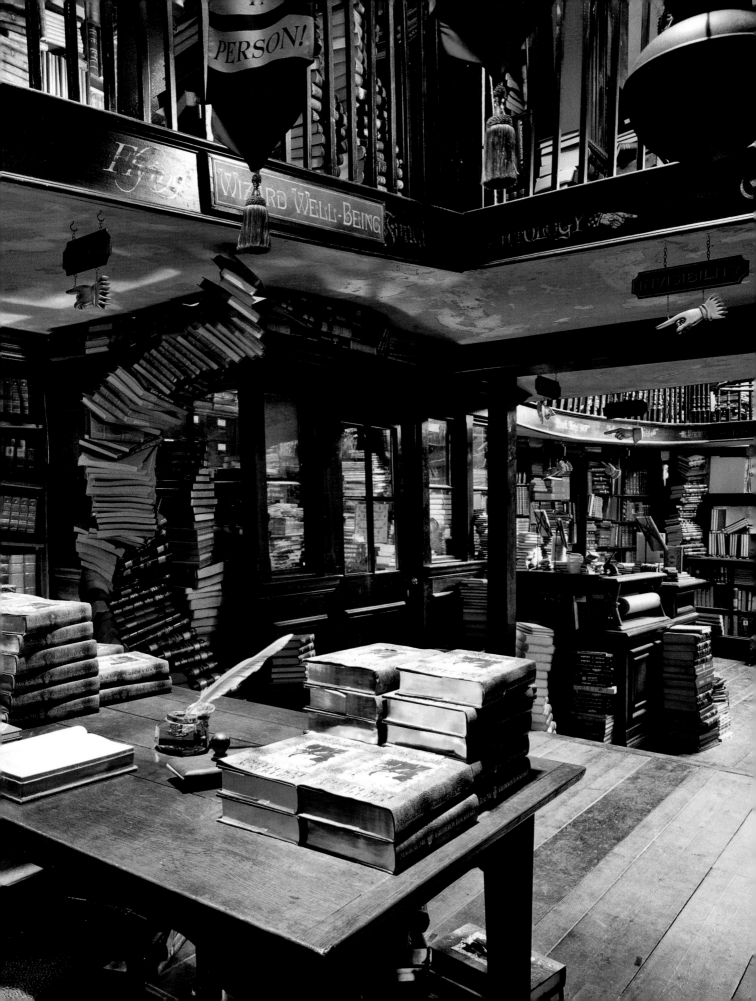

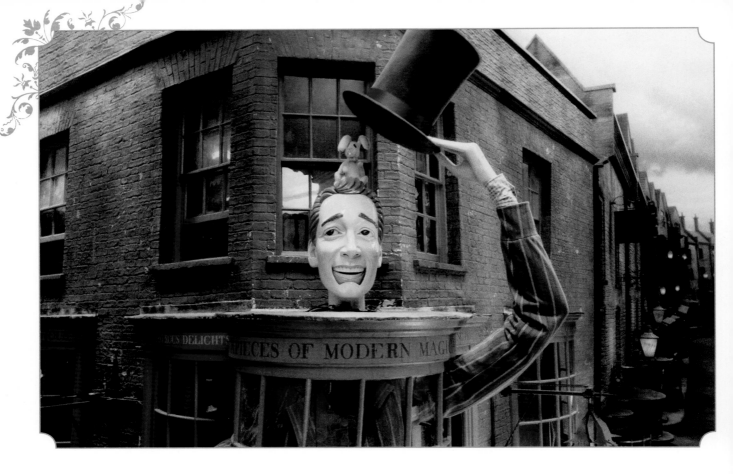

WEASLEYS' WIZARD WHEEZES

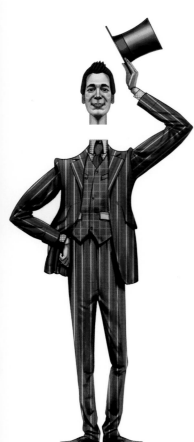

Fred and George Weasley open a business on Diagon Alley in *Harry Potter and the Half-Blood Prince*. Weasleys' Wizard Wheezes sells practical jokes, love potions, defensive magic products, and their signature Skiving Snackbox, along with many other magical items. The tall, purple-painted building is fronted by a twenty-foot-tall moving figure of one of the Weasley twins clad in the signature Weasley orange color. Debate still occurs as to which brother is the model: Actor James Phelps (Fred Weasley) claims it's him "because I'm the better-looking one," but actor Oliver Phelps (George Weasley) maintains it's him because his is "the funnier face." The statue has moving eyes and eyebrows, and it raises and lowers a top hat covering an appearing and disappearing rabbit, just the first of many plays on Muggle jokes in the store.

In the film, the tall building stands out on Diagon Alley, not only because most of the street's shops were recently destroyed by Death Eaters but because it contrasts with the production's chosen color palette. Stuart Craig always tries to find ways to make his sets cohesive, and for Diagon Alley, he limited the number of colors. "In the case of the Weasleys' shop," Craig explains, "we needed to break

with that practice, so made it brighter and cleaner than anything else we've done. It needed to leap out at you deliberately."

The three-story shop features shelves crammed with thousands of boxes, bottles, and packages, all labeled by the graphics department. "At first, our paper and designs were pretty and delicate," Miraphora Mina recalls, "and then Stuart said, 'Can you please make it more vulgar?' So we looked at packaging for fireworks and firecrackers, because they're really cheap and disposable and the printing is always wrong." Graphics scanned in textures and colors to use, which, Eduardo Lima adds, "don't always print out the way you'd want, especially on the poor quality paper we used, which to us was an advantage." The artists also went to shops that sold kitschy items and brought back tins and other containers, which they often altered and added to their stores. "I think we created about one hundred and forty different product designs," says Lima. "And then we would need to make two hundred of an item, four hundred of another, even two

LEFT: *Concept art for the moving figure featured on the Weasleys' Wizard Wheezes storefront.* ABOVE: *The doffing of the figure's hat reveals a rabbit.* OPPOSITE: *The colorful, overloaded set of Weasleys' Wizard Wheezes.*

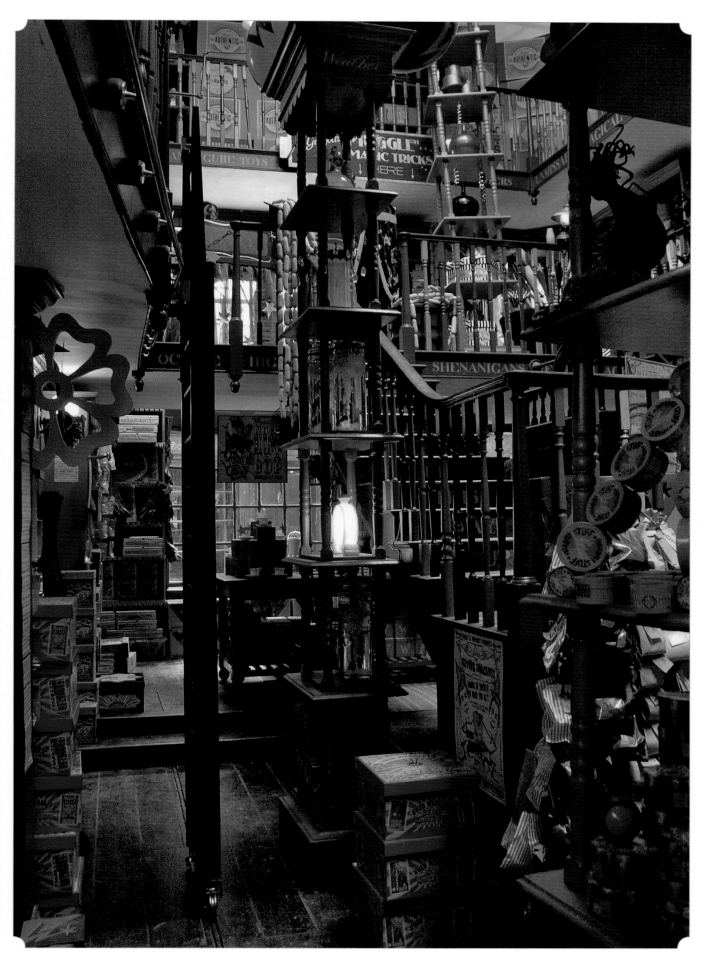

thousand of some," recalls Mina. "All made by our crew in-house. Like elves." It took weeks to create all the toys and gags, and it took several weeks more to stock the shelves in the store. The graphics department also created shopping bags, order forms, receipts, and all of the store's display signage.

Several large display stands and dispensers added to the fun. Concept designer Adam Brockbank channeled the garish toys and large, crudely sculpted figures that were used for charity donations outside British stores in the 1950s. "There is the Ten-Second Pimple Vanisher," Brockbank explains, "for a pimple cream, so we thought, 'How about a head where the pimples come up and then disappear back down again?'" It was crafted by prop maker Pierre Bohanna and his team, who also manufactured the six-foot-tall Puking Pastilles dispenser. "We wanted that to be funny and disgusting at the same time," says Brockbank. "This was a girl throwing up a never-ending stream of Puking Pastilles into a bucket, so you can just put your cup under to fill it up and go pay." Pierre Bohanna's department also created thousands of green-and-purple pastilles to be "puked," in addition to numerous Nosebleed Nougats, Fainting Fancies, and Fever Fudge candies. Says James Phelps (Fred Weasley), "The set for Weasleys' Wizard Wheezes had so much in it that you could stay in there for days and not see it all."

"STEP UP, STEP UP. WE'VE GOT FAINTING FANCIES, NOSEBLEED NOUGAT . . . AND JUST IN TIME FOR SCHOOL, PUKING PASTILLES."

Fred and George Weasley, *Harry Potter and the Half-Blood Prince*

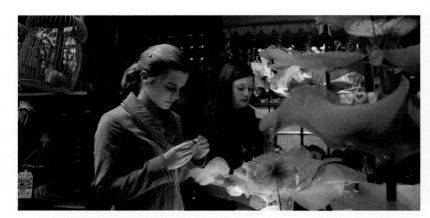

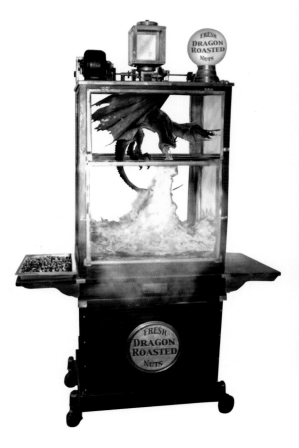

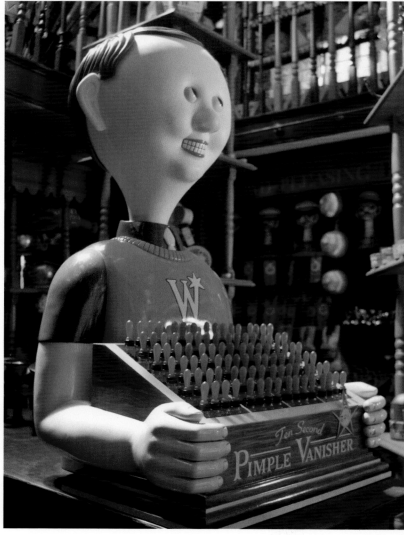

TOP: *Hermione (Emma Watson) and Ginny (Bonnie Wright) examine love potions.* ABOVE AND OPPOSITE: *Large, intricate, and interactive displays were crafted for the Weasleys' Wizard Wheezes set.* LEFT: *A schematic of the "dragon-roasted" nut cart placed outside the joke shop.*

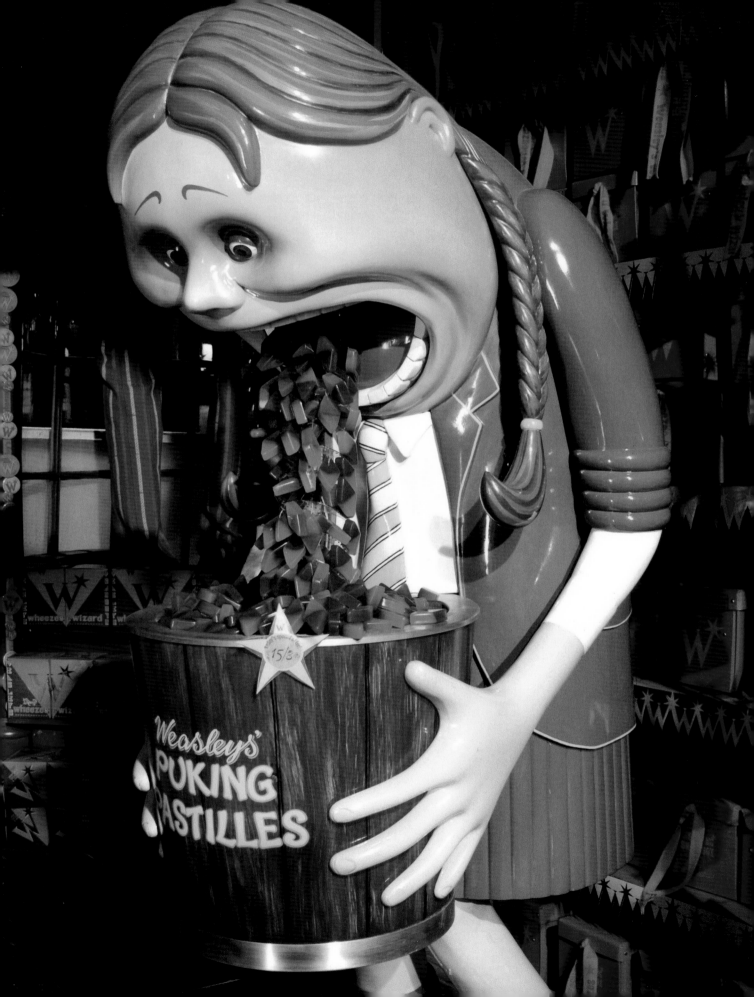

ELEVATION AA SECTION BB SECTION CC SECTION EE SECTION GG

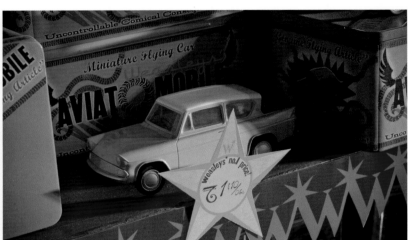

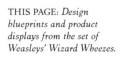

THIS PAGE: *Design blueprints and product displays from the set of Weasleys' Wizard Wheezes.*

OCCUPANTS:
Fred Weasley,
George Weasley

**FILMING
LOCATION:**
Leavesden Studios

APPEARANCE:
*Harry Potter and the
Half-Blood Prince*

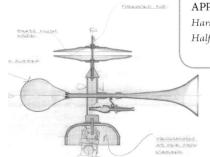

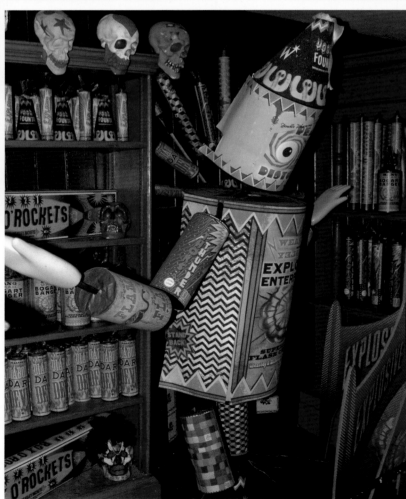

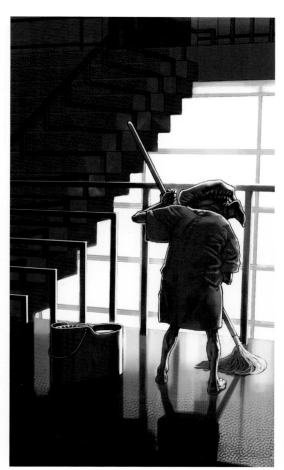

ST MUNGO'S HOSPITAL FOR MAGICAL MALADIES AND INJURIES

As often happens, there were places and scenes described in the Harry Potter books that were written into the film scripts but did not make it on-screen. For the scenes in *Harry Potter and the Order of the Phoenix* when Arthur Weasley is attacked by Nagini, Voldemort's snake, visual development art was created for St Mungo's Hospital, but those scenes were cut from the final shooting script.

THIS PAGE, CLOCKWISE FROM TOP LEFT: *In concept art by Adam Brockbank, a house-elf in scrubs mops the floor, Quidditch players accompany an injured team member, and strange ailments afflict those in the waiting room.*

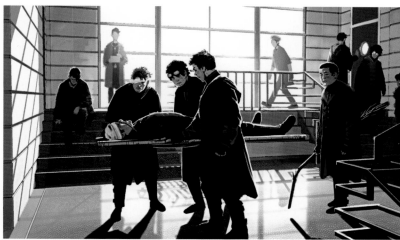

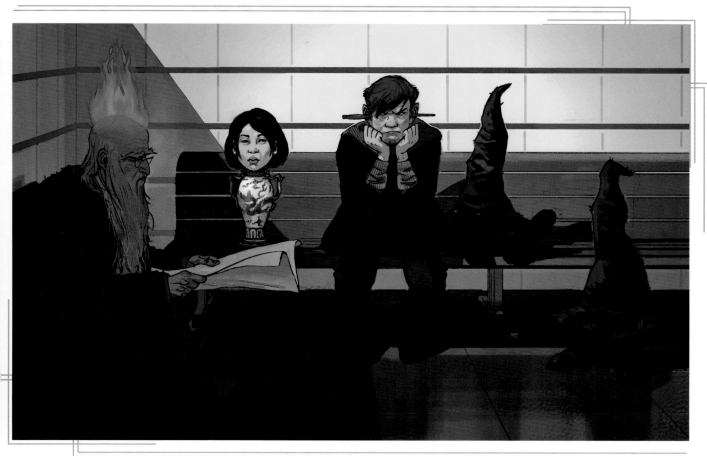

KNOCKTURN ALLEY

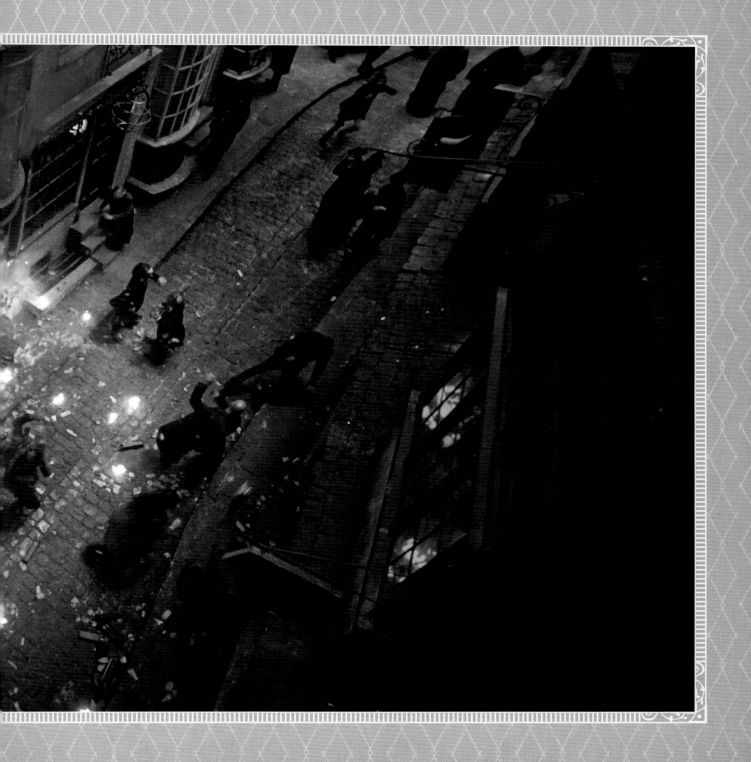

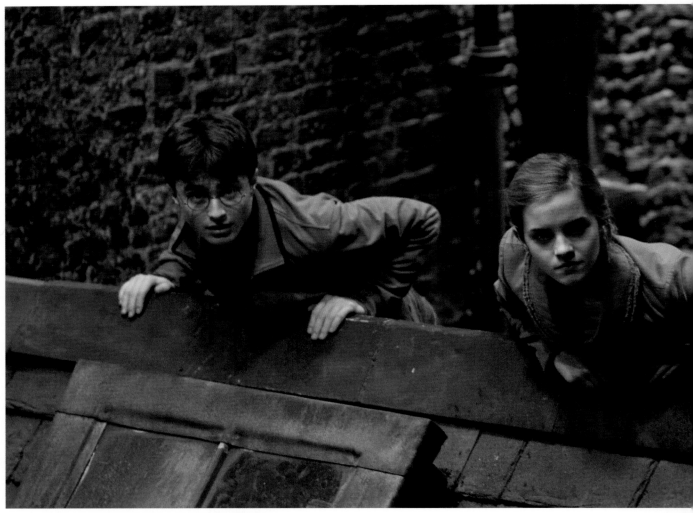

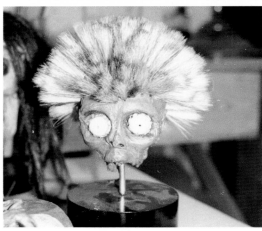

KNOCKTURN ALLEY

When Harry Potter uses the Floo Network for the first time in *Harry Potter and the Chamber of Secrets*, he mispronounces his intended destination—Diagon Alley—and ends up one fireplace grate too far, emerging in a side street known as Knockturn Alley. After dusting off ashes and adjusting his broken glasses, Harry finds himself in Borgin and Burkes, an antiques shop that deals in artifacts associated with the Dark Arts. Trying to find his way back to Diagon Alley, he's rescued by Hagrid, who has to answer to what he is doing in the dubious passageway.

Stuart Craig employed architecture similar to that of Diagon Alley, with the buildings of Knockturn Alley bearing the same noticeable lean. But many of its lifeless shops are bow-fronted, resulting in curved windows that burst from blackened brick walls. While Diagon Alley has light and color, Knockturn Alley is, not surprisingly, filled with shadows.

Borgin and Burkes—established in 1863—has the same architectural facade as Ollivanders wand shop, albeit with darker qualities to it. Inside, shelves and glass cabinets hold an array of candleholders, urns, skulls and other bones, jewelry, and exotic statues. Props director Pierre Bohanna brought in a taxidermist to show his team a real shrunken head as reference for set dressing. The wood used in the shop for boxes, counters, and cupboards was ebonized in the same way as in Ollivanders. Sharp eyes will notice a jeweled necklace lying in a velvet frame near a cabinet—the same cursed opal necklace that the unfortunate Katie Bell touches in *Harry Potter and the Half-Blood Prince*.

OCCUPANTS: Questionable witches and wizards, Borgin

FILMING LOCATION: Leavesden Studios

APPEARANCES: *Harry Potter and the Chamber of Secrets, Harry Potter and the Half-Blood Prince*

"HARRY, IS IT ME OR DO DRACO AND
MUMMY LOOK LIKE TWO PEOPLE WHO
DON'T WANT TO BE FOLLOWED?"

Ron Weasley, *Harry Potter and the Half-Blood Prince*

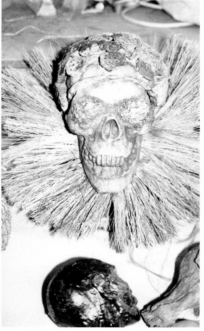
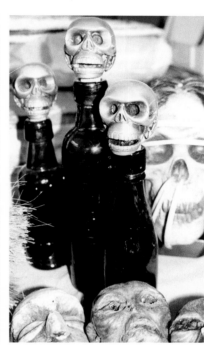

Harry shows great curiosity about the artifacts and makes the mistake of touching the Hand of Glory, a magical object coveted by thieves. It grasps his hand and won't let go until Harry manages to pry it off. There were two versions of the Hand made for the film—a static one and a mechanized prop that held Daniel Radcliffe's hand very tightly.

In a scene deleted from the final film, Draco Malfoy and his father, Lucius, visit Borgin and Burkes in order for the latter to sell some items that might prove embarrassing to him if they are uncovered in a Ministry of Magic raid prompted by the Muggle Protection Act. Through the shop window, Draco spots Harry caught by the Hand of Glory, but before the two can confront each other, Harry breaks free and hides himself in a Crushing Cabinet. The tall sarcophagus-like case was based on torture devices of the Middle Ages called Iron Maidens. Fortunately, this cabinet is empty within, and Harry is safe from Draco's prying eyes.

Harry returns to Knockturn Alley in *Harry Potter and the Half-Blood Prince*; this time accompanied by Ron and Hermione. Diagon Alley has been nearly destroyed by Death Eaters, and as the trio takes in the ruined shops, they see Draco with his mother, Narcissa, trying to enter Knockturn Alley without being noticed. They follow the Malfoys to Borgin and Burkes through narrow,

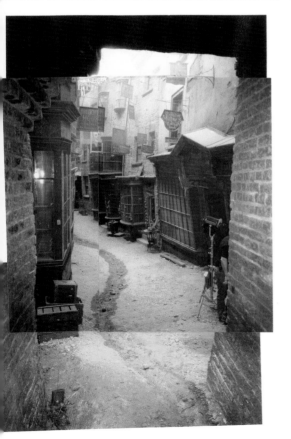

OPPOSITE TOP: *Daniel Radcliffe, Emma Watson, and Rupert Grint on the Knockturn Alley set.* OPPOSITE BOTTOM AND ABOVE: *Shrunken heads and skulls for Borgin and Burkes are displayed in the props department.* LEFT: *Set photos for* Harry Potter and the Chamber of Secrets.

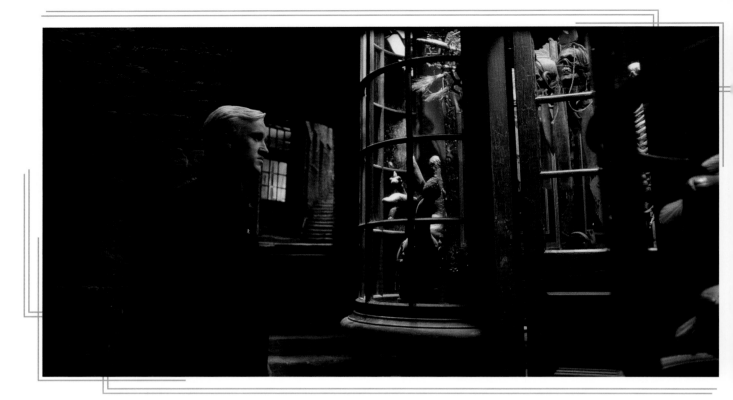

arched brick lanes barely wide enough for two, which contribute to the cramped and dangerous feeling of the location. Led by Borgin, the Malfoys pass through the store and through a small courtyard to a two-story warehouse-type building adjacent to the shop, where they're joined by Fenrir Greyback, the werewolf.

The alleyways are covered in wanted posters of known Death Eaters, such as Bellatrix Lestrange and the Carrow siblings, Amycus and Alecto. Because of the damage inflicted by the same and others upon that area of London, the posters created by Miraphora Mina and Eduardo Lima were torn and stained and appeared damaged by rough weather as well.

In Borgin and Burkes, Draco is examining what Harry later discovers is a Vanishing Cabinet. Vanishing Cabinets were all the rage when Voldemort first came to power, Arthur Weasley tells Harry, because you could disappear within them. They also provided a way to travel between locations. It's discovered that the Vanishing Cabinet in Knockturn Alley has a twin at Hogwarts, specifically in the Room of Requirement. Draco has been tasked with ensuring that the Vanishing Cabinet at Hogwarts is working properly, for the Death Eaters have plotted to use it as a way to enter and take over the school.

In *Half-Blood Prince*, the Room of Requirement is overflowing with artifacts and detritus, so production designer Stuart Craig chose a strong, tall silhouette for the Vanishing Cabinet as a contrast. "Director David Yates wanted the cabinet to look mysterious and threatening," says art director Hattie Storey. "Stuart saw this as the best way to convey that feeling in a set overflowing with an eclectic array of other props and furniture." The dark, obelisk-shaped cabinet has an intricate brass locking mechanism created by Mark Bullimore, special effects supervising engineer, who also designed the locks for Gringotts Wizarding Bank and the Chamber of Secrets.

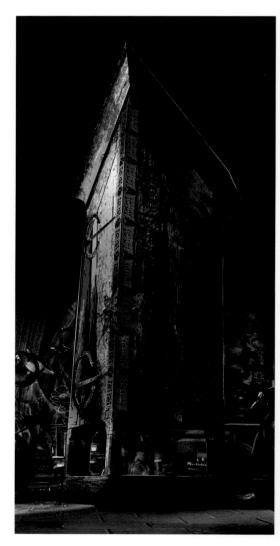

TOP: *Draco Malfoy pauses outside Borgin and Burkes,* Harry Potter and the Half-Blood Prince. RIGHT: *Concept art for the Vanishing Cabinet by Adam Brockbank.* OPPOSITE TOP: *Storyboards trace the route Harry, Ron, and Hermione take while following Draco Malfoy in* Half-Blood Prince. OPPOSITE BOTTOM: *Wanted posters from* Half-Blood Prince.

we catch a glimpse of the fenir going over the roof tops towards the back of Borgin and Burkes.

CUT
frame A

CUT
frame B

Three shot Harry, Hermione and Ron against the low wall.

EXTRA DIALOGUE
HERMIONE
We shouldn't be here!!

BG A pack of snarling dogs along alley...

Cont'd
frame C

...PAN
to see the pack of dogs pulling a small dirty boy up the steps...

Se 25/26
Page 17 of 29
10th April 2008

Cont'd
frame B

CUT
frame A

START on Harry running...
He scales a drain pipe and clambers over the roof...

TILT with him.

Hermione looks round the wall.

HERMIONE
Harry. Are you mad?

Ron puts his finger to his lips then slowly withdraws it. He mouths 'sorry'.

CUT
frame C

Se 25/26
Page 20 of 29
10th April 2008

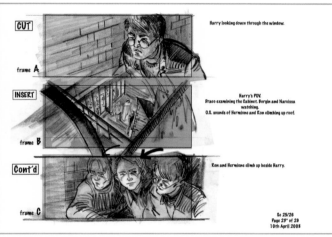

CUT
frame A

Harry looking down through the window.

INSERT

Harry's POV.
Draco examining the Cabinet. Borgin and Narcissa watching.
O.S. sounds of Hermione and Ron climbing up roof.

frame B

Cont'd
frame C

Ron and Hermione climb up beside Harry.

Se 25/26
Page 28 of 29
10th April 2008

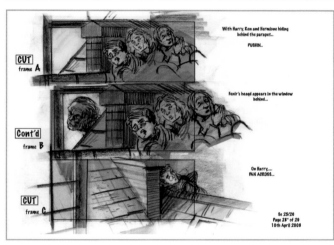

CUT
frame A

With Harry, Ron and Hermione hiding behind the parapet...

PUSHIN..

Cont'd
frame B

Fenir's head appears in the window behind..

On Harry....
PAN ACROSS...

CUT
frame C

Se 25/26
Page 28 of 29
10th April 2008

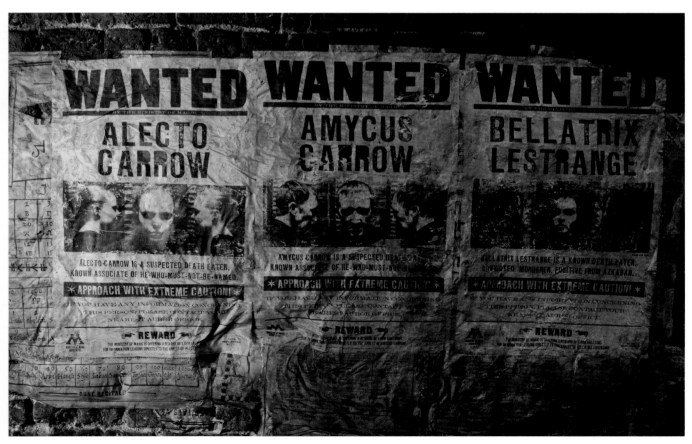

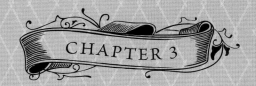

CHAPTER 3

THE HOGWARTS EXPRESS

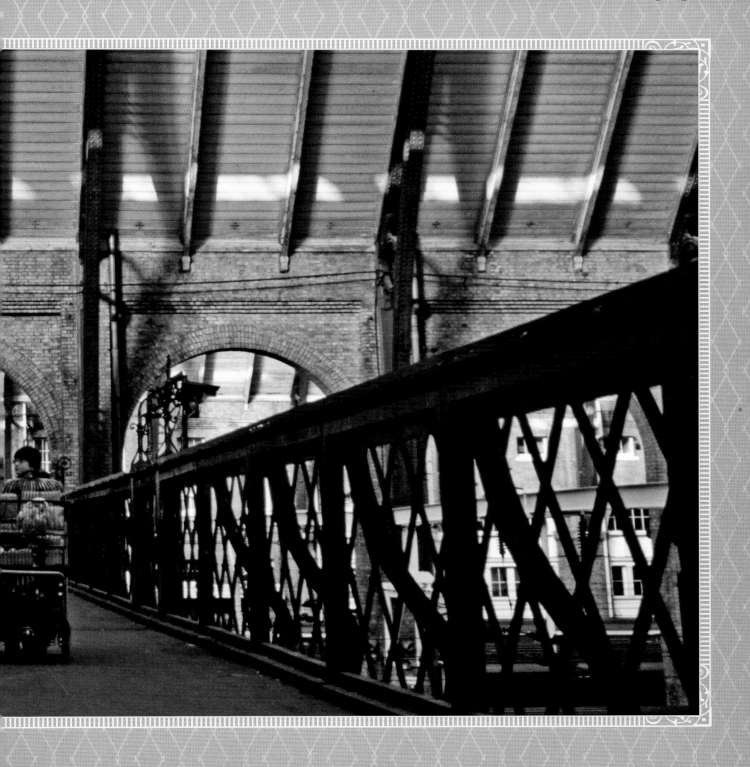

KING'S CROSS STATION

King's Cross station is the London departure point for the Hogwarts Express, which transports students to Hogwarts School of Witchcraft and Wizardry. First seen in *Harry Potter and the Sorcerer's Stone*, King's Cross station, built in the Victorian era, sports two eight-hundred-foot-long train sheds topped by barrel-vaulted roofs that rise to over seventy feet. The vastness of the station makes even Hagrid look small as he and Harry stop on one of the sky bridges, where Hagrid gives Harry his ticket to the Hogwarts

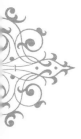

> "NOW, UH, YOUR TRAIN LEAVES IN TEN MINUTES. HERE'S YOUR TICKET. STICK TO IT, HARRY, THAT'S VERY IMPORTANT. STICK TO YOUR TICKET."

Rubeus Hagrid, *Harry Potter and the Sorcerer's Stone*

Express. For *Harry Potter and the Order of the Phoenix*, Stuart Craig chose to set the scene when the Weasleys bring Harry to the station against the more elaborately designed Victorian Gothic exterior of St Pancras station, its neighbor, rather than using the plain front of King's Cross. Inside, Harry once again crosses the sky bridge, this time accompanied by Sirius Black in his Animagus form as a black dog, as Sirius sees Harry off at the beginning of the school year.

In *Harry Potter and the Deathly Hallows – Part 2*, Harry finds himself in a dreamy, improbable version of the station, where he encounters Albus Dumbledore. The interior of King's Cross station—possibly only created in Harry's mind—is reinvented in a bright white. The station was actually mostly imagined by the special effects team. Daniel Radcliffe (Harry Potter) and Michael Gambon (Albus Dumbledore) shot their scene on a white stage, instead of against green screen,

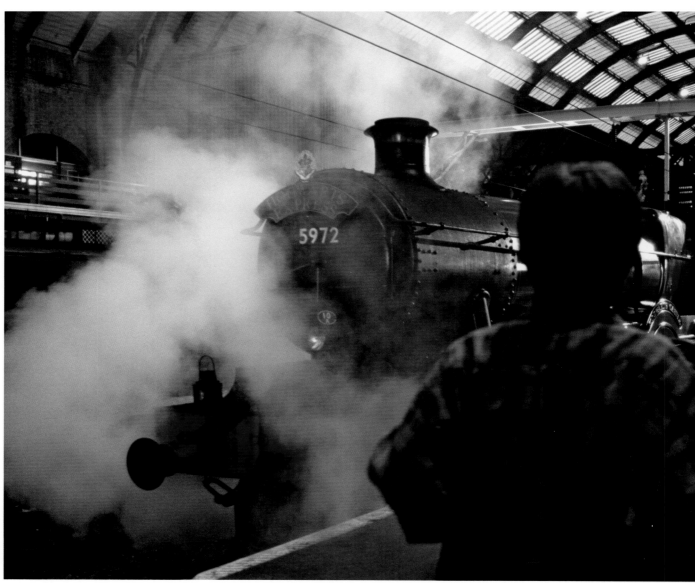

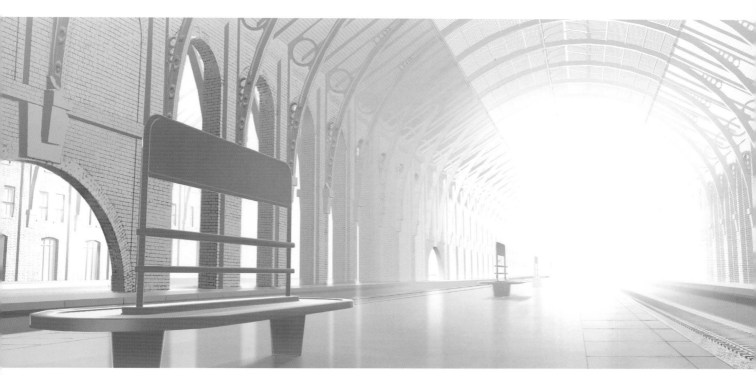

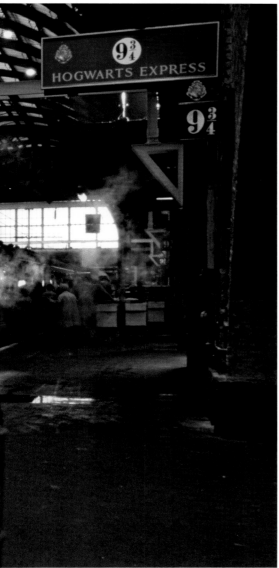

OCCUPANTS: Hogwarts students and families

FILMING LOCATIONS: King's Cross station and St Pancras station, London, England

APPEARANCES: *Harry Potter and the Sorcerer's Stone, Harry Potter and the Chamber of Secrets, Harry Potter and the Order of the Phoenix, Harry Potter and the Deathly Hallows – Part 2*

which allowed for enhanced lighting effects. The filmmakers' initial thought was to have the station look almost like an ice palace, but when rendered, it did not deliver the emotional environment everyone wanted. Special effects went back to the drawing board (or rather the computer keyboard) and started from a simpler concept. Instead of having the station re-created with realistic details, they removed the walls and arches, leaving the roof, the columns, and the platforms, to give it a sense of ethereal infiniteness. A bright horizon line, which added an additional light source, and a dimensional mist were added. Pleased with the outcome, the producers and director asked for one more thing: Very subtly, the columns phase in and out of opaqueness to add to the otherworldly feel.

TOP: *Concept art for the clean and white King's Cross station seen toward the end of* Harry Potter and the Deathly Hallows — Part 2. ABOVE: *Harry Potter and Albus Dumbledore (Michael Gambon) at King's Cross station in* Harry Potter and the Deathly Hallows — Part 2. OPPOSITE: *Harry approaches the Hogwarts Express at Platform Nine and Three-Quarters in* Harry Potter and the Sorcerer's Stone.

"BUT HAGRID, THERE MUST BE A MISTAKE. THIS SAYS PLATFORM NINE AND THREE-QUARTERS. THERE'S NO SUCH THING . . . IS THERE?"

Harry Potter, *Harry Potter and the Sorcerer's Stone*

PLATFORM NINE AND THREE-QUARTERS

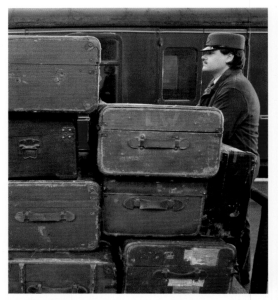

After Rubeus Hagrid hands Harry his ticket for the Hogwarts Express in *Harry Potter and the Sorcerer's Stone*, Harry is left to get to Platform Nine and Three-Quarters by himself. Though he finds platforms nine and ten, he's baffled at what to do next. Fortunately, the wizarding Weasley family arrives and shows Harry how to go through a brick wall to get onto a hidden platform.

It would be natural to assume that the filmmakers would use King's Cross station's real platforms nine and ten for the location shoot. But as Stuart Craig explains, "Platforms nine and ten are not in the main station building, but in a little annex to the side." Craig wanted to showcase the station's Victorian architecture and get a strong image: "We chose a platform that had big brick piers, under big supporting arches that connected to another platform, which gave it a substantial wall to run at before they pass through it to the other side." Platform Nine and Three-Quarters was actually set between platforms four and five.

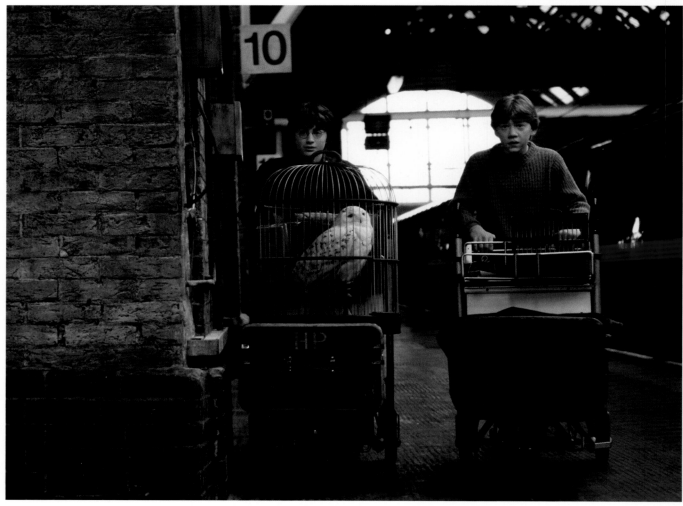

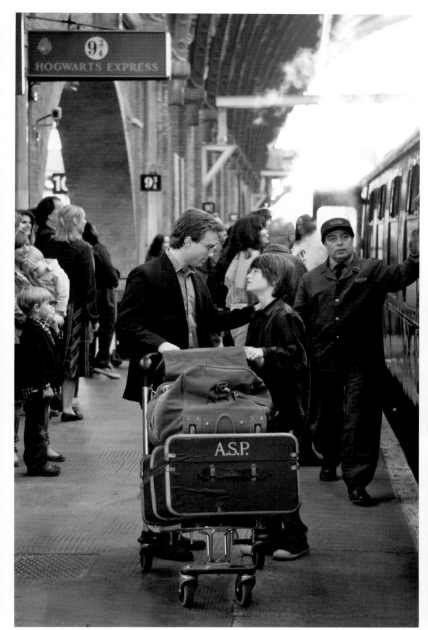

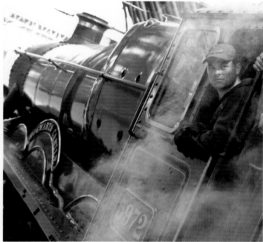

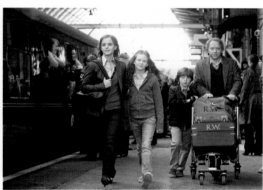

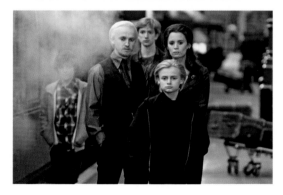

Throughout the films, going through the wall to the platform was achieved digitally. However, as *Sorcerer's Stone* director Chris Columbus preferred to use practical effects when possible, he did have a brick-walled passageway constructed in the studio for Daniel Radcliffe (Harry) to run through for the first time. The King's Cross location was filmed on a Sunday, when the station would be least crowded. And it was uncrowded—that is, until weekend passengers noticed the shoot. Recalls Columbus, "We had pulled the real Hogwarts Express onto the platform's tracks, and had replaced the sign with the one for Platform Nine and Three-Quarters. There was a tremendous amount of visitors that day who couldn't believe they were actually seeing the train at King's Cross station." In *Harry Potter and the Deathly Hallows – Part 2*, nineteen years after Harry's graduation from Hogwarts, he, Ginny, Ron, and Hermione return to Platform Nine and Three-Quarters: now, as parents accompanying their children, who are taking the train as Hogwarts students. Once again, the platform held not only the train but, nearby, delighted onlookers.

THIS PAGE: *Images from* Harry Potter and the Deathly Hallows — Part 2 *show the next generation of Potters, Weasleys, and Malfoys getting ready to board the Hogwarts Express.*
OPPOSITE, TOP TO BOTTOM: *Old and weathered suitcases were used as props; the young Harry Potter and Ron Weasley (Rupert Grint) push their inscribed luggage onto Platform Nine and Three-Quarters in* Harry Potter and the Sorcerer's Stone.

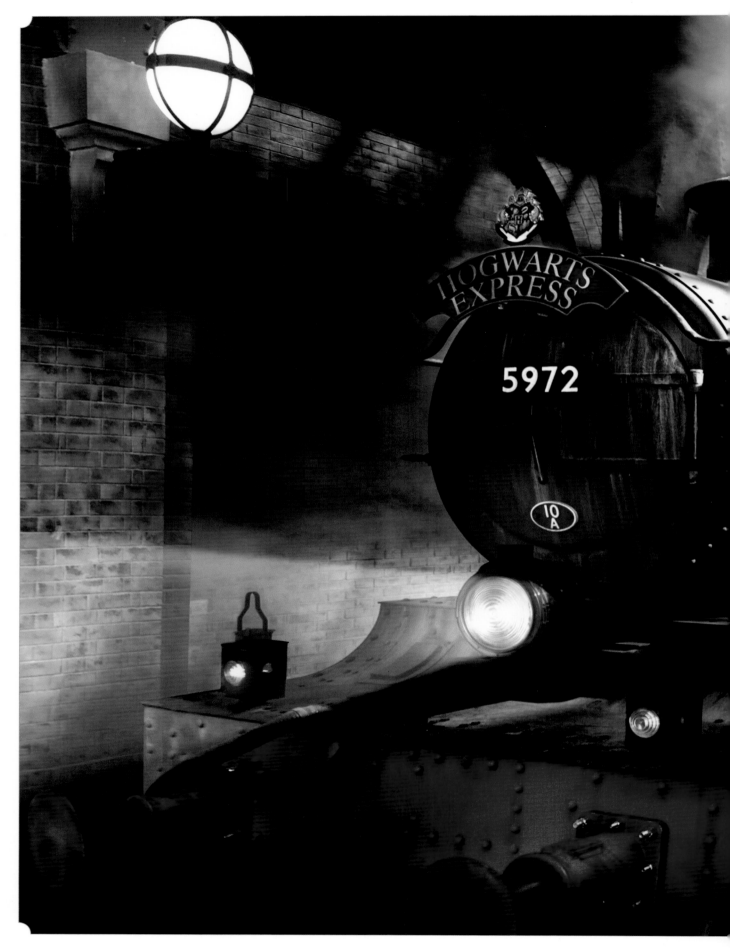

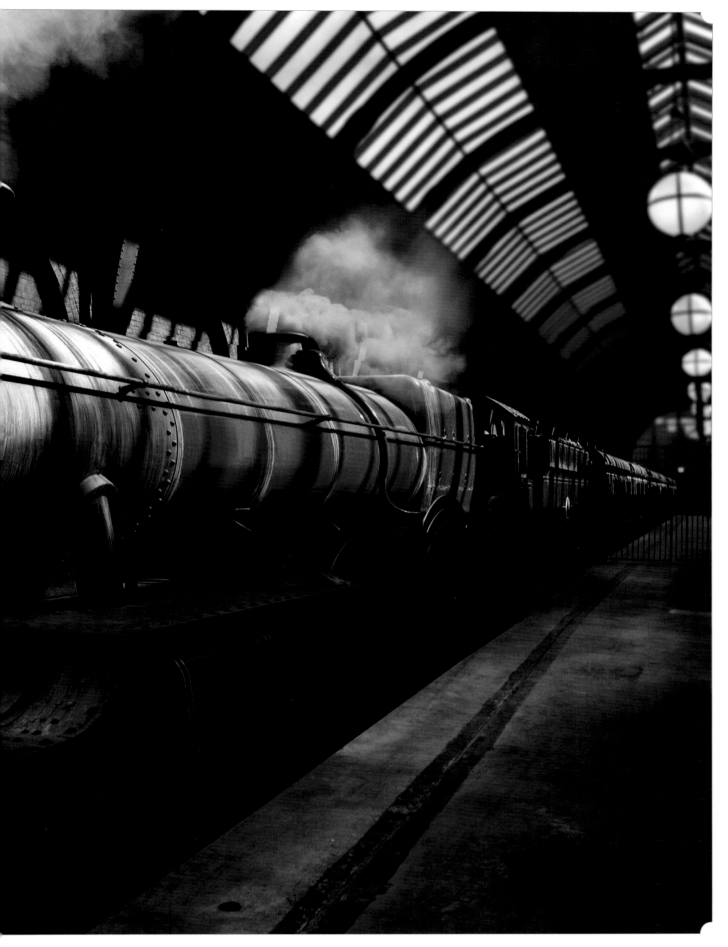

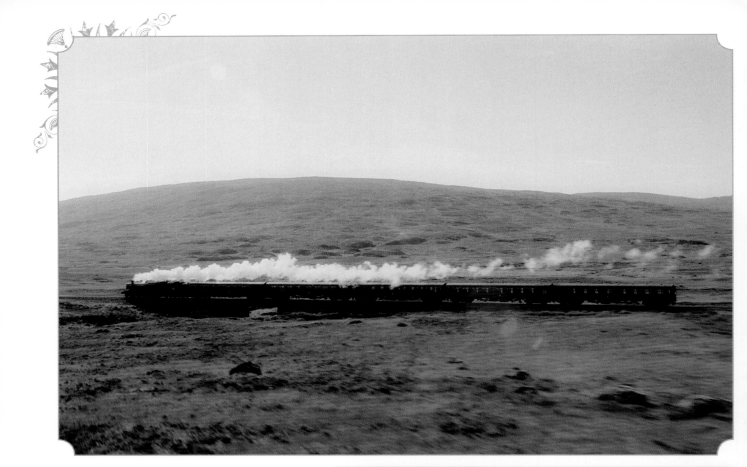

THE HOGWARTS EXPRESS

The Hogwarts Express appears in all of the Harry Potter films. The train brings new and returning students from London to Hogsmeade, where students finish their journey to Hogwarts by other means, and the train returns students to London at the end of the school year. To create the Hogwarts Express, the filmmakers rescued an abandoned steam locomotive named *Olton Hall* (no. 5972). Built in 1937 by the Great Western Railway, *Olton Hall* ran until 1963, when, sadly, it ended up in a South Wales scrap yard. After it was found in 1997, *Olton Hall* was fully restored for use in *Harry Potter and the Sorcerer's Stone*. The train was painted crimson, which is the antithesis of the traditional Great Western Railway standard color of Brunswick green. The engine itself was fitted with new nameplates, as it was now called "Hogwarts Castle," and it pulled four British Rail Mark 1 carriages. In between the movies, the train was used as a tourist train between Scarborough and York and as the Shakespeare Express to Stratford-upon-Avon.

PREVIOUS PAGES: *Part of the Platform Nine and Three-Quarters station platform was re-created at a soundstage at Leavesden, complete with track and trains.* TOP: *A still from* Harry Potter and the Half-Blood Prince, *shot from helicopter.* MIDDLE AND RIGHT: *Signage and nameplates used on the trains.* OPPOSITE: *A view of the Hogwarts Express locomotive, previously named* Olton Hall *(no. 5972).*

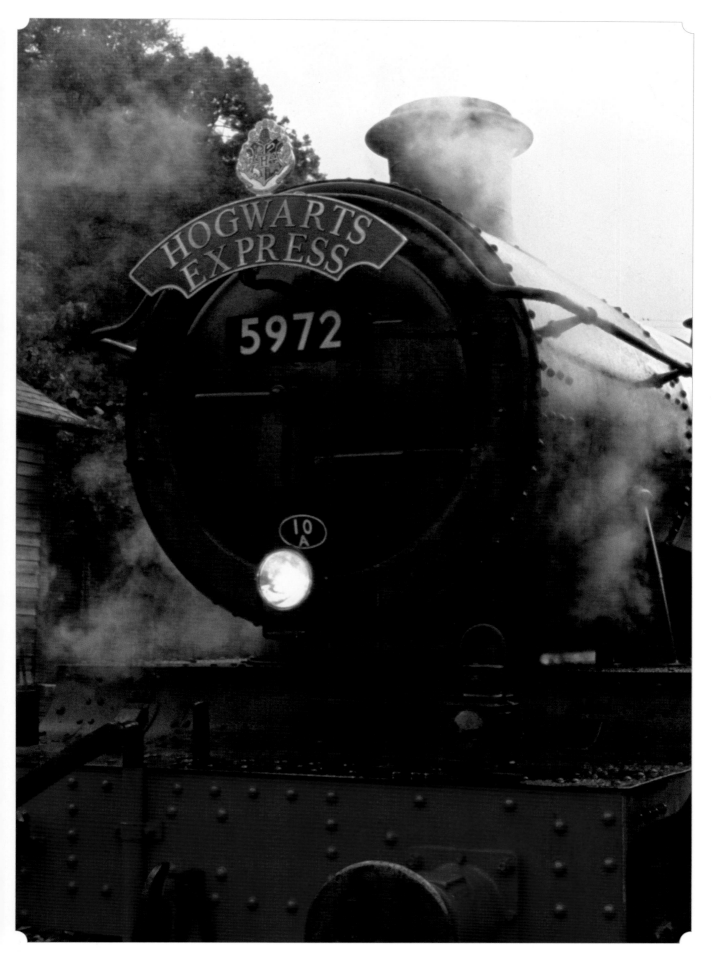

"ANYTHING OFF THE TROLLEY, DEARS?"

Trolley witch, *Harry Potter and the Sorcerer's Stone*

The interiors and exteriors of the Hogwarts Express weren't filmed at the same time. "Unfortunately, we couldn't shoot the scenes on a real train traveling through Scotland, so we utilized helicopter shots of the train, and then we shot the compartments in front of a green screen," notes *Harry Potter and the Sorceror's Stone* director Chris Columbus.

The look of the train's interior compartments was influenced by one of Columbus's favorite movies: *A Hard Day's Night*, filmed in 1964, starring the Beatles. "It may be my favorite film of all time," Columbus says. "And I wanted the compartments to feel exactly like those John, Paul, George, and Ringo were riding in at the beginning of the movie. And Stuart Craig re-created the look of that train."

RIGHT: *The Trolley witch pauses by a compartment in Harry Potter and the Sorcerer's Stone.* BELOW: *The young actors were allowed to stuff themselves with candy on set.* OPPOSITE TOP: *The dated, weathered compartments were the result of a conscious decision by Sorcerer's Stone director Chris Columbus.* OPPOSITE BOTTOM: *The Hogwarts Express passing by a home for sale in an image that wasn't used in the films.*

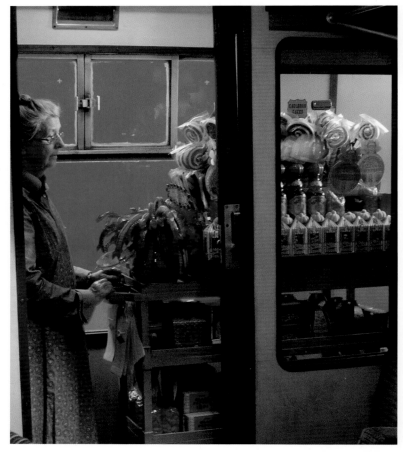

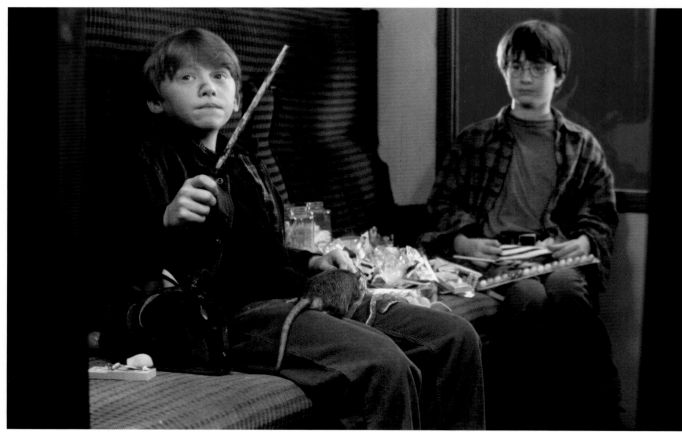

OCCUPANTS: Hogwarts students, the Trolley witch

MACHINE: *Olton Hall* (no. 5972)

APPEARANCES: *Harry Potter and the Sorcerer's Stone, Harry Potter and the Chamber of Secrets, Harry Potter and the Prisoner of Azkaban, Harry Potter and the Goblet of Fire, Harry Potter and the Order of the Phoenix, Harry Potter and the Half-Blood Prince, Harry Potter and the Deathly Hallows – Part 1, Harry Potter and the Deathly Hallows – Part 2*

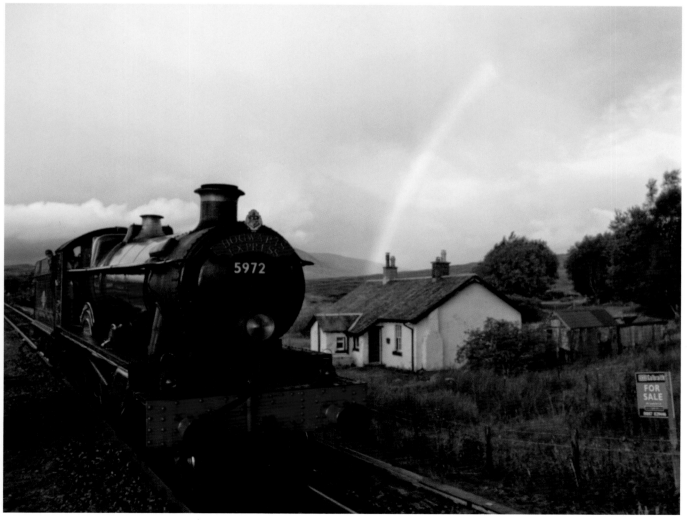

THE MINISTRY OF MAGIC

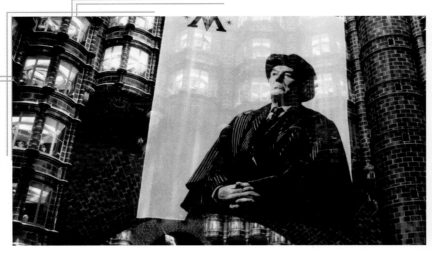

MINISTRY OF MAGIC

Stuart Craig wanted to ensure that the Ministry of Magic would have the gravitas necessary to represent any austere body of government, and as this would be the largest set built at the studio, he also wanted a great visual. "I asked myself several questions," he recalls. "What would give it credibility? What would allow me to take a visual approach? What would separate this set from all the others and make it unique and interesting?" His first task was deciding where to place it. "First, this is an underground world, but foremost, this is a ministry. We decided that our magical ministry was a kind of parallel universe to the Muggle ministry, so we thought it would be fun to set it beneath the British government's Ministry of Defense." As research for the subterranean location, Craig and crew

"I DON'T UNDERSTAND. WHAT HAS THE MINISTRY OF MAGIC GOT AGAINST ME?"

Harry Potter, *Harry Potter and the Order of the Phoenix*

visited the London Underground's network of tunnels and stations. "We visited the oldest of the London Tube stations, built in the early 1900s, many of which used an extravagant amount of decorative ceramic tile. The use of ceramic was logical, of course, because of its being below the waterline. But the colors of the tiles and the use of classical columns and decorative elements were inspirational to the design, and photographically very interesting." Craig also knew that, as the interior was underground, there would be no natural lighting, and using high-gloss glazed tiles would reflect what light there was. The Ministry Atrium was constructed with deep reds, greens, and blacks that surrounded huge gilded fireplaces connected to the Floo Network. Craig likened the area to Waterloo station at eight in the morning. "There's that huge concourse leading into this massive corridor, which we first see with everybody going to work, except that instead of trotting off from trains, they appear down fireplaces."

Each Ministry worker was fitted with a briefcase and other business necessities. Set decorator Stephenie McMillan also provided the Atrium with a newsstand to sell the *Daily Prophet* and a café trolley that provided coffee and pastries named "Ministry Munchies." But "the Ministry is a bureaucracy," Craig reminds us, "and rather sinister developments are happening. [Minister for Magic] Fudge is a dominating, iconic figure." Craig and director David Yates were inspired by early Soviet Union–style propaganda posters to place a large banner of Cornelius Fudge in the Atrium, which watches over the workers.

ABOVE: *A banner hangs in the Atrium depicting a proud and strong Cornelius Fudge (Robert Hardy), Minister for Magic.* RIGHT: *In concept art by Andrew Williamson, Harry is accompanied by Arthur Weasley on the way to a trial he faces for producing a Patronus in the presence of a Muggle.*

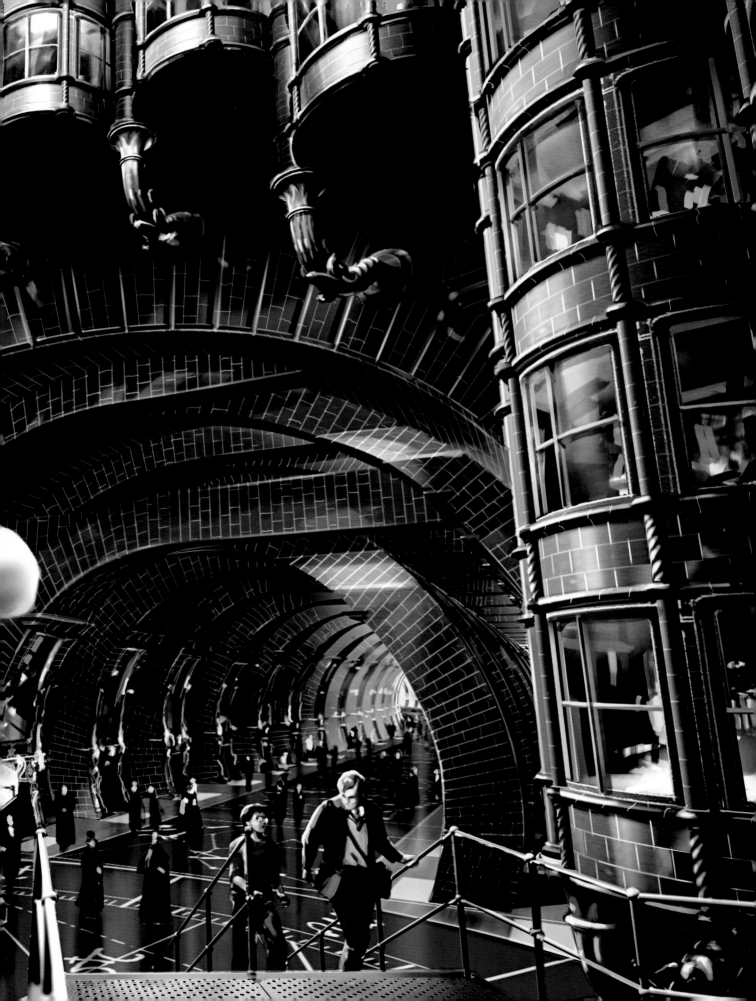

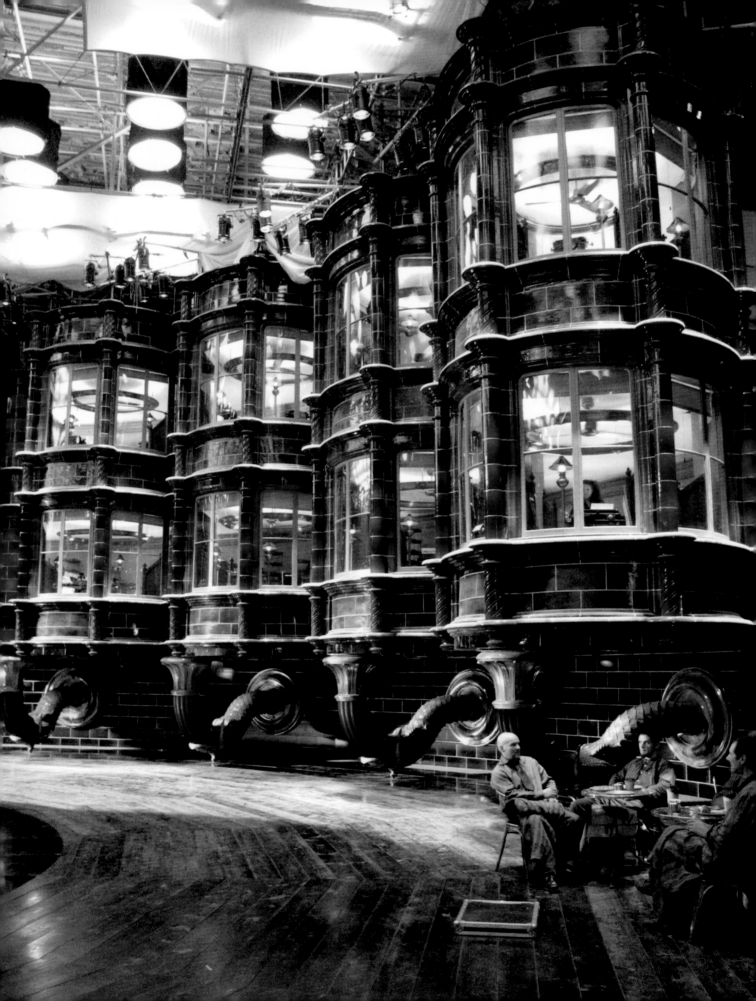

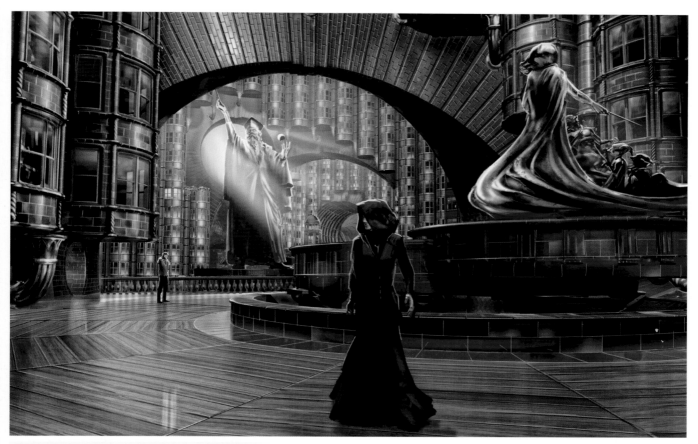

"There's an artificiality about it being underground," offers Craig, "with no outlook on the world." The physical set is over two hundred twenty feet long, and this is extended even further via CGI, which quadruples what is seen on-screen. "But it's only as high as the stage would allow us—we had only thirty feet of working height," notes Craig. Only two stories of the Ministry's endless columns of windowed offices could be constructed, with the rest rendered digitally. Stephenie McMillan was required to dress these fourteen offices, and in order to fit with the wizarding world setting, none of the office equipment could have electricity. "We're never allowed any electricity," McMillan says with a laugh. "So each office was decorated with a typewriter and with oil lamps with especially tall stems. We needed to use cardboard filing cabinets and filing drawers at the back of the rooms because otherwise there would be a weight problem." In fact, only stuntmen were allowed to inhabit the offices.

In the climax of *Order of the Phoenix*, Dumbledore and Voldemort wage a magical battle in the Atrium that at one point blasts out what would appear to be the more than two hundred windows of the Ministry offices. Special effects supervisor John Richardson used practical explosive effects combined with additional debris. "The practical part of it had to work on the first take," Richardson recalls, "and I'm glad to say it did." In typical moviemaking fashion, the destructive battle in the Atrium was scheduled first, requiring a massive cleanup to return the location back to its gleaming state before the opening scenes of the sequence could be filmed.

OCCUPANTS: Ministers for Magic Fudge, Scrimgeour, and Thicknesse, Ministry workers

FILMING LOCATION: Leavesden Studios

APPEARANCES: *Harry Potter and the Order of the Phoenix, Harry Potter and the Deathly Hallows – Part 1*

OPPOSITE: *Stand-ins sit back on the Atrium set.* TOP: *Concept art by Andrew Williamson shows a cloaked woman crossing the Atrium in* Harry Potter and the Order of the Phoenix. *ABOVE LEFT: Another piece by Williamson shows the Atrium devastated after a battle between Lord Voldemort and Dumbledore.*

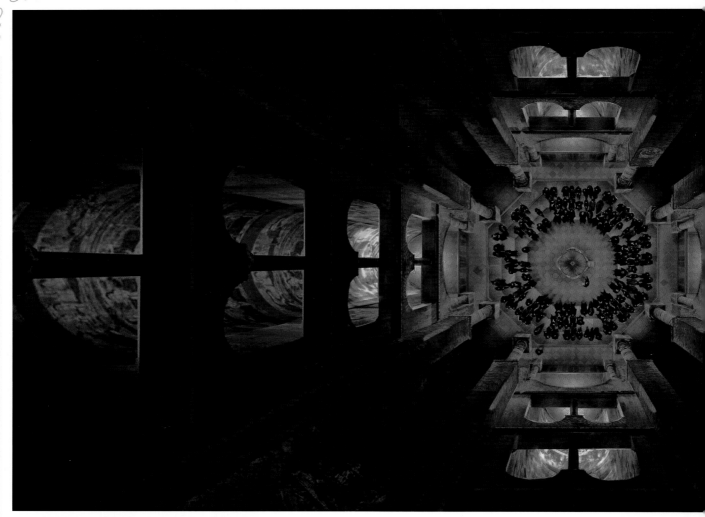

TRIAL CHAMBER

When Harry Potter first looks into the Pensieve in Dumbledore's office in *Harry Potter and the Goblet of Fire*, he enters one of Dumbledore's memories of Death Eater trials held by the Council of Magical Law in the Ministry of Magic's trial chamber. Since, from Harry's perspective, he "falls" into the courtroom, verticality was a necessity, and with the help of visual effects, the descent from the top of the octagonal chamber's ceiling is sixteen stories high (about 160 feet). Stuart Craig designed the room in a style not yet seen in the films: "My inspiration came from ancient Byzantine churches. The city of Byzantium is where Istanbul, in Turkey, now is, and [it was] part of the Roman Empire in the fifth century. The style features round arches and domes, unlike the prevalent Gothic style of so many locations." The choice of using an ancient culture's style gave the court the sense of being ancient itself. Though the chamber's tight configuration gives it a sense of constriction and intimidation, the room can actually seat two hundred people. "It's a more oppressive, darker look than we've had in the previous movies," Craig explains, "but it needed to manifest the mood of the sequence." As the trial chamber is deep within the Ministry, it has no source of exterior light. Four huge fires glow red and gold from recesses within the tall alcoves. The inlaid floor and surrounding columns were finished with marbleized paper, using the same technique as for the floors of Gringotts Wizarding Bank (and for the giant Wizard's Chess board in *Harry Potter and the Sorcerer's Stone*): dipping sheets of paper in vats layered with water and oil paint, and finishing them off with brushwork. The numerous marble columns were also gilded to reflect the firelight. The room has decayed with time; the walls are cracked and layered in

OCCUPANTS: Council of Magical Law, Death Eaters

FILMING LOCATION: Leavesden Studios

APPEARANCES: *Harry Potter and the Goblet of Fire, Harry Potter and the Order of the Phoenix, Harry Potter and the Deathly Hallows – Part 1*

"THE CHARGES AGAINST THE ACCUSED ARE AS FOLLOWS . . ."

Cornelius Fudge, *Harry Potter and the Order of the Phoenix*

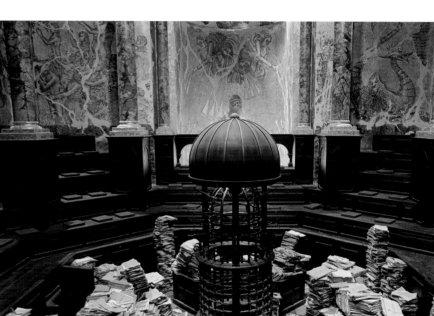

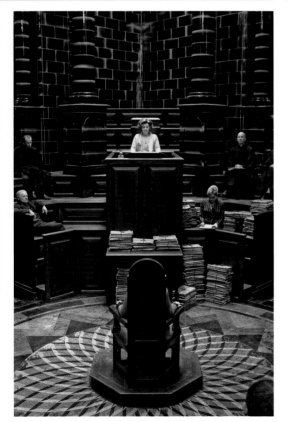

peeling paint. Also featured on the walls are murals inspired by those in Byzantine churches, reinterpreted with wizardly iconography. At the center of the trial chamber is a metal cage that imprisons the focus of the council's questioning in Dumbledore's memory. "It's similar to medieval iron maidens," he explains. "Director Mike Newell was keen on having it seem an instrument of torture, so we added very threatening spikes turned in toward the witness inside."

In *Harry Potter and the Order of the Phoenix*, Harry is called to the trial chamber to face charges for underage wizardry. The trial chamber was rethought and expanded for this film. "We literally doubled it," Craig says. "It retains its symmetry, which was important, but we built another octagon and put the two together." The room is clear of the paperwork piled up in its previous incarnation, and it dovetails more with the tiled design of the Ministry Atrium and concourse. Though doubled, there are still only four firelit light sources, and the room sinks into dark, sterile shadows.

A disguised Harry, Ron, and Hermione sneak into the courtroom in *Harry Potter and the Deathly Hallows – Part 1* to steal the Horcrux locket worn by Dolores Umbridge. Perhaps this is a different room, for the trial chamber has now shrunk back to a single octagon and is encased in a dark green-black ceramic tile.

THESE PAGES, CLOCKWISE FROM TOP LEFT: *Concept art depicts the octagonal chamber as seen from above; a still from* Harry Potter and the Goblet of Fire *highlights the chamber's gold leaf columns and Byzantine frescoes; for the trial in* Harry Potter and the Order of the Phoenix, *the room was widened to incorporate the Victorian tile seen in the film; the cage for prisoners was modeled on medieval torture instruments.*

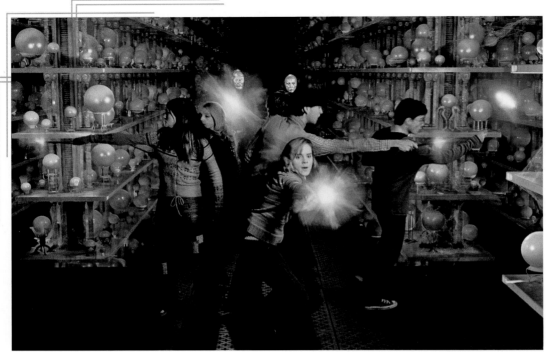

HALL OF PROPHECY

Lured by a false vision planted by Voldemort, Harry Potter races to the Ministry's Department of Mysteries to save Sirius Black in *Harry Potter and the Order of the Phoenix*. Accompanied by his friends from Dumbledore's Army—Ron and Ginny Weasley, Hermione Granger, Neville Longbottom, and Luna Lovegood—he enters a room that is filled with hundreds of globes of all sizes—the Hall of Prophecy.

The Hall of Prophecy was the first entirely virtual set created for the Harry Potter films. The decision to create it digitally was not an easy one. "We did quite a lot of test shooting and had endless debate," Stuart Craig explains. "To start with something built and to extend it seamlessly through CGI is not always easy.

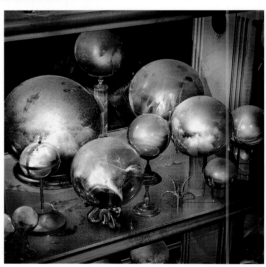

"HARRY? IT'S GOT YOUR NAME ON IT."

Neville Longbottom, *Harry Potter and the Order of the Phoenix*

THESE PAGES, CLOCKWISE FROM TOP LEFT: *Harry, Ron, Hermione, Neville, Luna, and Ginny are pursued by Death Eaters through the Hall of Prophecy; a blueprint for the orbs and shelves that were built prior to computer rendering; concept art by Andrew Williamson depicts the myriad shelves of the hall; a sampling of real orbs was created by the props department; the hall shelves were marked with numbered plates.*

Sometimes it's better to create the entire world." The lighting of the room and its contents was perhaps the most convincing factor against building a real set. "We wanted the prophecies themselves to be some kind of low-level source of ambient light, and brighten and dim when the students walked by them," he explains. "It's very difficult to do that without them looking like some kind of light fixture. By generating it in the computer, you can have all of the magic and all of the subtlety in the world."

Initial concepts did require a small portion of the set to be created practically. Stephenie McMillan and her team were asked to build a cross section of the shelving and populate it with

labeled prophecy orbs that ranged from two inches to eighteen inches in size. "I think we were supposed to make about thirteen thousand globes, altogether," she recalls, "which would be used for the background. The ones in front would be done by special effects." But a new consideration quickly arose. At the conclusion of the scene, shelf after shelf of glass orbs would fall and smash—something the filmmakers knew should be achieved digitally so that the actors would be safe. This sealed the decision to go digital. McMillan, the consummate prop recycler, used some of the orbs as drink dispensers on the Ministry Munchies coffee cart. The scene was filmed in a green-screen room that had a path marked on the floor and simple skeletal frames of shelving for the actors to negotiate, all of which offered the digital artists a logical geography to the hall. Then the digital shelves and globes were duplicated ad infinitum.

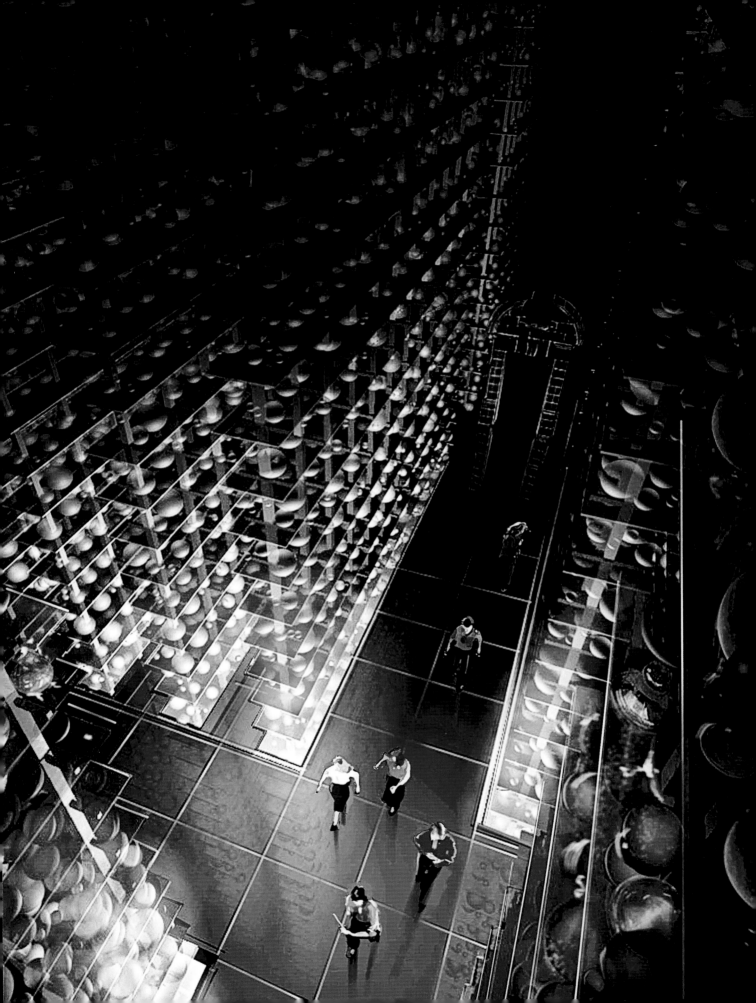

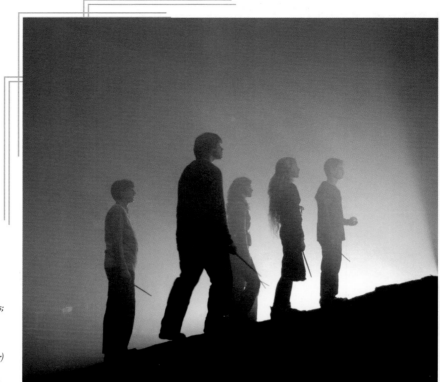

THESE PAGES, CLOCKWISE FROM TOP LEFT: *Harry and members of Dumbledore's Army enter the Department of Mysteries; concept art depicts the battle in which Sirius Black falls through the Veil to his death; Bellatrix Lestrange (Helena Bonham Carter) and Sirius Black (Gary Oldman) on the Department of Mysteries set.*

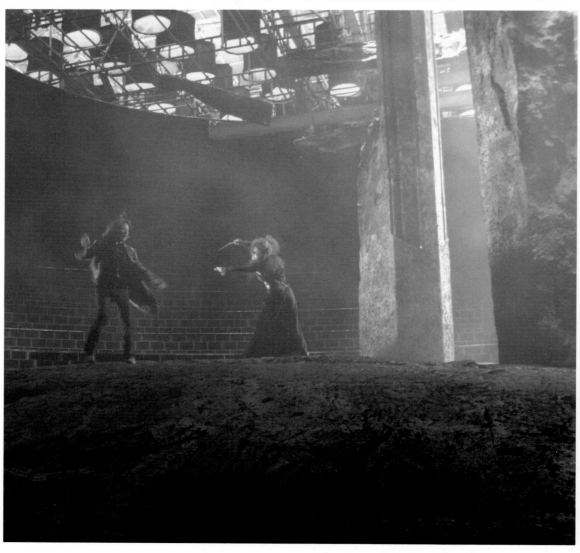

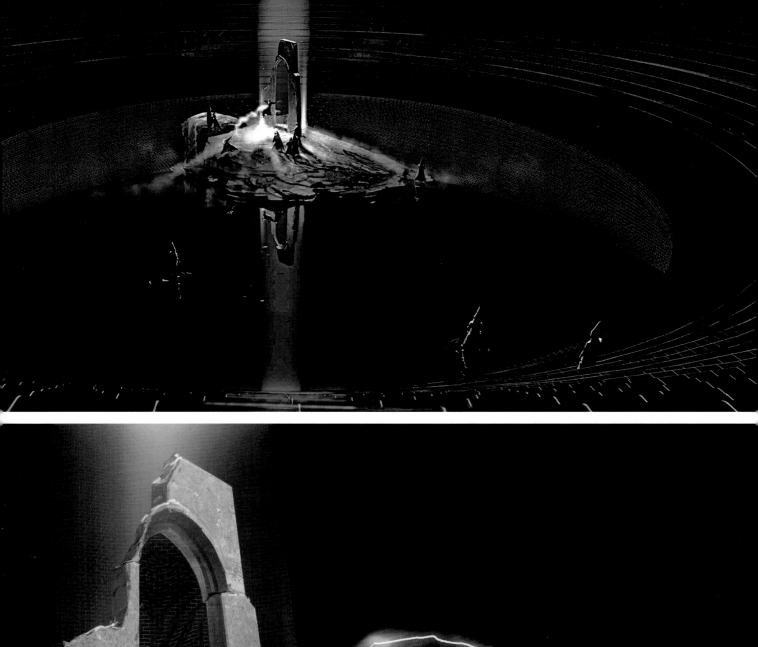
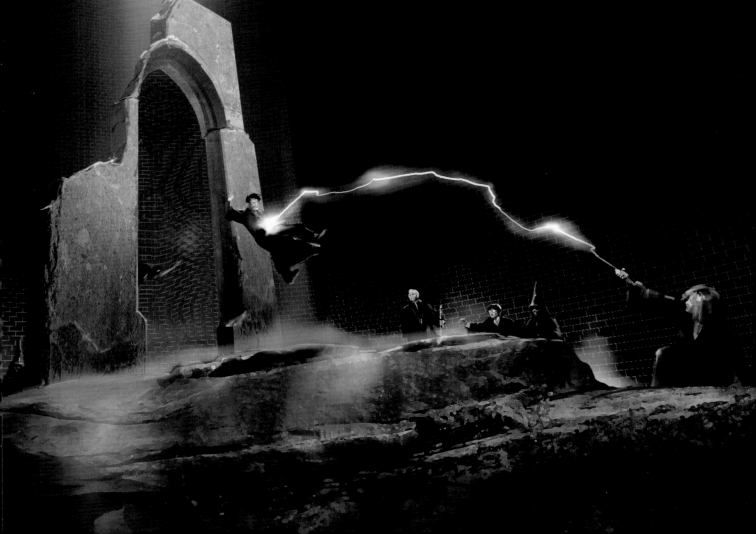

MUGGLE-BORN REGISTRATION COMMISSION AND OFFICE

OCCUPANT: Dolores Umbridge

APPEARANCE: *Harry Potter and the Deathly Hallows – Part 1*

In *Harry Potter and the Deathly Hallows – Part 1*, Harry Potter enters the Ministry of Magic while disguised by Polyjuice Potion, and he makes his way to the Muggle-Born Registration Commission (a new department put in place to pursue Muggle-born wizards) to search for the Horcrux locket Dolores Umbridge now possesses.

In a large, black-tiled room, the Muggle-Born Registration Commission actively collates propagandist literature that soars from the desks to receiving in-boxes. "We made forty-eight desks for the clerks who were making anti-Muggle brochures under this huge, arched vaulted set," says Stephenie McMillan. The room is bordered by gold columns topped with ornate Corinthian-order capitals. The room's carpet is purple, a color that Stuart Craig had been slowly adding as an accent to the Ministry style, outlined by a Greek key design.

Dolores Umbridge's new office is, as Stuart Craig describes it, "another essay in pink," although he admits that "as the films have become darker, the sets as well have literally become darker." Umbridge's office is set facing the Atrium of the Ministry, so there is a light source that floods the room, but it is dimmed by the dark greenish-black tiled walls. The tops of the gold Corinthian columns seen in the office pool are now substantially larger, sitting on top of tiled column bases. "But Umbridge's office in the Ministry still has a lot of the elements, and quite a lot of the furniture, that had been in her Hogwarts office," says McMillan. The pink rug and the spiky French furniture have transferred over, as well as a majority of the kitten plates, although the dark office did not warrant the use of the blue-screened filmed moving cats.

THESE PAGES: *Concept art by Andrew Williamson shows the office where a pool of clerks create anti-Muggle brochures (below and bottom right) outside Dolores Umbridge's private office (opposite top).*

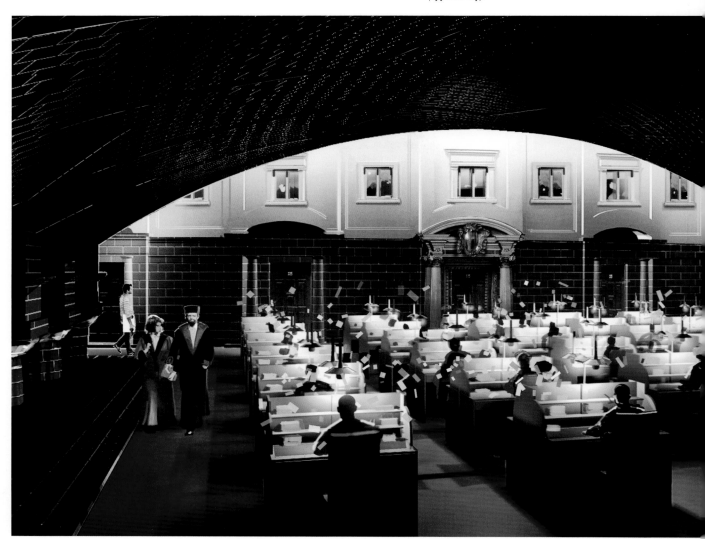

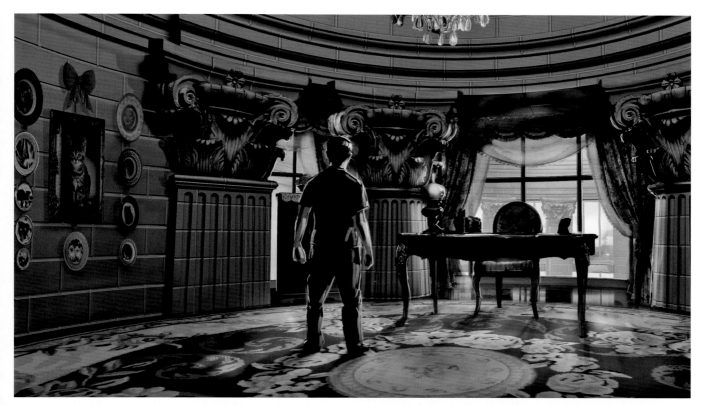

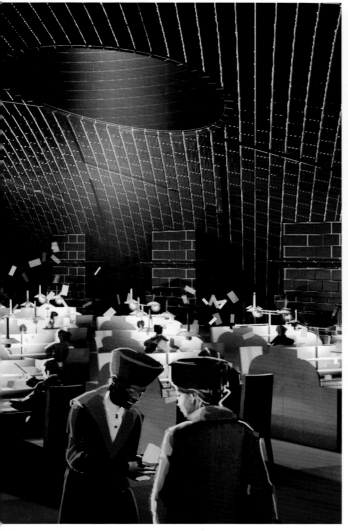

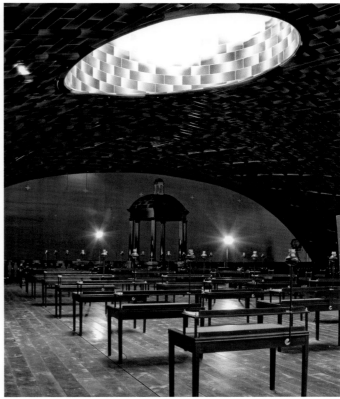

"MUDBLOODS & THE DANGERS THEY POSE TO
PEACEFUL, PUREBLOOD SOCIETY."

Pamphlet distributed by the Muggle-Born Registration Commission,
Harry Potter and the Deathly Hallows – Part 1

ISBN: 978-1-68383-747-3

INSIGHT
EDITIONS

PO Box 3088
San Rafael, CA 94912
www.insighteditions.com

Publisher: Raoul Goff
Associate Publisher: Vanessa Lopez
Creative Director: Chrissy Kwasnik
Designer: Judy Wiatrek Trum
Editor: Greg Solano
Editorial Assistant: Jeric Llanes
Senior Production Editor: Rachel Anderson
Senior Production Manager: Greg Steffen

Text by Jody Revenson

Insight Editions, in association with Roots of Peace, will plant two trees for each tree used in the manufacturing of this book. Roots of Peace is an internationally renowned humanitarian organization dedicated to eradicating land mines worldwide and converting war-torn lands into productive farms and wildlife habitats. Roots of Peace will plant two million fruit and nut trees in Afghanistan and provide farmers there with the skills and support necessary for sustainable land use.

Manufactured in China by Insight Editions

10 9 8 7 6 5 4 3 2 1